MW00615861

Ghosts Stories of St. Petersburg, Clearwater and Pinellas County

Ghosts Stories of St. Petersburg, Clearwater and Pinellas County

Tales from a Haunted Peninsula

Deborah Frethem

Published by Haunted America
A Division of The History Press
Charleston, SC 29403
www.historypress.net

Copyright © 2007 by Deborah Frethem
All rights reserved

Cover design by Marshall Hudson.

First published 2007
Second printing 2010

Manufactured in the United States

ISBN 978.1.59629.307.6

Library of Congress Cataloging-in-Publication Data
Frethem, Deborah.
Ghosts stories of St. Petersburg, Clearwater, and Pinellas County : tales
of a haunted peninsula / Deborah Frethem.
p. cm.
Includes bibliographical references (p.).
ISBN 978-1-59629-307-6 (alk. paper)
1. Ghosts--Florida. 2. Ghost stories--Florida. I. Title. II. Title:
Ghosts stories of Saint Petersburg, Clearwater, and Pinellas County.
BF1472.F6F74 2007
133.109759'63--dc22
2007034952

Notice: The information in this book is true and complete to the best of our knowledge. It
is offered without guarantee on the part of the author or The History Press. The author
and The History Press disclaim all liability in connection with the use of this book.

All rights reserved. No part of this book may be reproduced or transmitted in any form
whatsoever without prior written permission from the publisher except in the case of
brief quotations embodied in critical articles and reviews.

To Craig, Geoffrey and Stephen for putting up with my idiosyncrasies over the years. And to Amanda and Nicole who actually chose this crazy family.

Contents

Contents

Acknowledgements

In 2004 my husband and I left behind our home and friends in Minnesota and headed for Florida. Our goal was to live someplace "where water was liquid all year-round." I knew that I had a job waiting for me in Madeira Beach. I had met Captain Mark Hubbard several months earlier, and he and I had agreed to begin a new venture doing historic tours in Pinellas County. Specifically, we wanted to start Tampa Bay Ghost Tours.

When I first talked about moving to the Tampa Bay area, people all told me, "You'll never find enough ghost stories down there to do a tour." Well, I not only found enough ghost stories to do one tour, I found enough to do four tours, and I'm finding new stories every day. In fact, there are so many stories that there is not even space for half of them in this book.

To be perfectly honest, my passion is not ghosts, although I am a believer. My passion is history. But I have found that people are much more interested in hearing history if it contains a good ghost story. I have also found that people who have had a brush with the supernatural love to share their experiences. Many such people were willing to recount those stories for this book.

The comfort level of those who share their stories with me is not all the same. Some are excited. Others are more reluctant. Some will tell their story, but don't wish to have their names revealed. But to all of them, I owe a debt of gratitude.

Also, my special thanks to Anne Wykoff, Rinita Anderson and the rest of the staff at the St. Petersburg Museum of History. Without their valuable assistance, my book would not have made it into print.

Acknowledgments

Thanks to Lynne Brown and Scott Taylor Hartzell, my friends and fellow historians.

Thanks to Mark Hubbard of Hubbard's Marina, Patricia Hubbard of Hubbard Enterprises, Kathleen McDole of the Friendly Fisherman Restaurant, Ron MacDougall of the Don CeSar, Dina Lomagno of the Belleview Biltmore, Robert and Karen Chapman of the Peninsula Inn and Spa, Bob and Geri Ruhlman of the Castle Hotel, Angie and MaryAnn of Comfort and Joy, Roland and Heather Martino of the Beach Drive Inn, Larry and Ellen Nist of the Larelle House Bed and Breakfast, Sherry Richards and Lynn Rucker of The Heritage and Stephanie Berlotti. And to many others who asked that their names not be used.

Thanks to my husband, Craig, for all of his support and his wonderful photographic advice.

Sharing the history behind these tales gives me great personal joy. It is an odd contradiction, that history can come alive through stories about the dead.

The Ghosts of John's Pass

JOHN LEVIQUE

Drive along Gulf Boulevard and you will pass over a bridge that connects Madeira Beach with Treasure Island. The body of water beneath that bridge provides passage between the Gulf of Mexico and beautiful Boca Ciega Bay. This passage is known as John's Pass. It was formed a relatively short time ago, cut by a huge storm in 1848. Before that time the land formed a solid barrier island. Those not from the area have occasionally been heard to refer to this straight of water as St. John's Pass. Truth be told, the man after whom the pass is named was anything but a saint.

Born in France in the waning years of the nineteenth century, John Levique was a poor lad without education. Unable to read and write, he always signed his name with an "X." At the age of ten he found employment aboard a Spanish vessel sailing back and forth between the old world and the new. Unfortunately, pirates captured this ship on John's very first voyage. The pirates (being the sweet, sensitive folk that they were) offered the young lad a choice. He could either join their pirate band and work as a slave in their galley, or they would slit his throat.

Understandably, the boy chose to live. As he grew up he became accustomed to pirate life and prospered, becoming cabin boy, mate, first mate and finally captain of his own ship. However, he was not the most successful of captains, most likely because he preferred not to kill people. Pirates of that time lived by the creed, "Dead men tell no tales," but John,

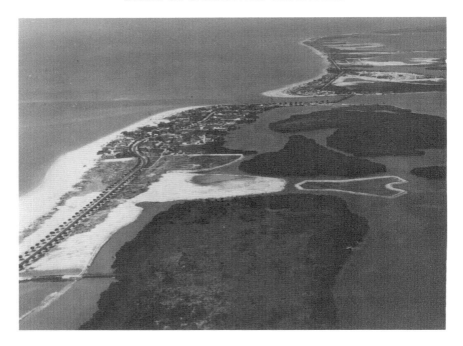

An aerial view of John's Pass. *Courtesy of St. Petersburg Museum of History.*

perhaps because of his own death threat as a young boy, preferred to let his victims live.

His lack of success led him to leave the pirate life in the early 1840s. He decided to retire to Florida, as so many do today, and chose the area we now call Madeira Beach as his new home. He brought with him one small chest of treasure, which he buried along the barrier island.

Levique then began his new career, that of turtle rancher. There were good reasons to become a turtle rancher in those days. Obviously, a fast horse was not required. But more importantly, turtles were an excellent cash crop. Turtle meat was prized as an ingredient for soup, an epicurean delight. Furthermore, turtles could be transported alive, a huge advantage in the days before refrigeration.

In the late summer of 1848, John and a friend named Joseph Silva took a boatload of turtles across the Gulf of Mexico to New Orleans, Louisiana. They were able to sell their cargo for quite a large profit. After spending quite a bit of that profit on wine, women and song in New Orleans, they headed home in September.

It was a dangerous gamble to cross the Gulf in September, the height of hurricane season. There was no Doppler radar or weather radio to warn of approaching storms. And sure enough, about halfway home, the two men noticed a huge storm growing on the horizon. They found a "hurricane hole" where they could ride out the storm. Although they had a rough time, they did survive and managed to resume their journey. When they arrived home, however, they found a completely changed shoreline, including a new pass that cut right through the barrier island. They sailed through the pass with John at the ship's wheel. Joseph remarked that this new pass must be "John's Pass," because John Levique was the first man to sail through it.

It's a sweet story. But it has a rather sad ending. The place where John had buried his one little treasure chest, all his profits from his pirating days, was exactly the place where the Great Gale of 1848 had cut the new water passage. John desperately hoped that his treasure had not been washed out to sea, but simply had been pushed off to one side of the pass or the other where it lay buried just beneath the sands of the beach. He spent the rest of his life looking for that treasure. He never found it and died just a few years later, a poor and broken man.

But the folks who live along those beaches today, as well as many who visit the area, claim to have seen John still walking the beaches, sometimes even in broad daylight. He is said to wear the rough clothing of a Florida pioneer. Over his left shoulder is slung a burlap sack, perhaps to gather turtle eggs along the beach. In his right hand he holds a long, sharp stick. He walks a few steps and then drives that stick down into the sand, wiggling it around, as if wondering, "Is there something down there? Is it worth digging?"

YANKEE BROTHERS IN SOUTHERN SOIL

Of course, the Civil War was the cause of great pain and strife throughout the country. And Florida was no exception. Despite the fact that it was not a plantation economy, Florida did become one of the Confederate States. But there were a few residents who felt very strongly that Florida should stay with the Union—strongly enough to enlist with the Union forces. Obviously, this was not a popular choice with some of their neighbors.

The island of Egmont Key was captured by Union forces in 1861. This island, just on the edge of the Tampa Bay shipping channel, is accessible

only by boat to this day. The Union navy used the island as a base from which to operate a blockade of the shipping lanes, thus preventing aid and comfort from reaching the Confederate forces. Conditions on Egmont Key were difficult. The island is mainly rock and sand, not suited for growing food. And, of course, hostile forces surrounded the small garrison. These conditions produced an unforeseen crisis—men on Egmont Key were slowly starving to death.

Among the navy men at Egmont Key were two brothers, John and Scott Whitehurst, who had been local farmers before the war. In late August of 1862, John and Scott decided they would take a boat to their own farms on the mainland, hoping to obtain much needed supplies, especially food for the forces on Egmont.

All went well at first. They returned home, loaded their boat with supplies and prepared to head back to the base. Unfortunately, just at that moment, they were set upon by a group of Confederate guerrillas who, according to official navy documents, killed Scott Whitehurst outright and mortally wounded John. However, he still managed to get his boat launched and out of the line of fire. But he lay in the boat drifting for two days, in the heat of a merciless August sun, before drifting onto land somewhere along the shores of John's Pass. Found by Union navy forces, John died on the evening of September 2, 1862. The Union navy vessel USS *Tahoma* retrieved the body of Scott Whitehurst, and the brothers were buried side by side.

However they are not at rest. Apparently, they continue to try and reach the safety of Egmont Key. And they are definitely creatures of habit, as their ghosts are only seen in the pre-dawn hours of the morning, after each new moon. The local fishermen, who are habitual early risers, most frequently see these spirits. They state that the ghosts of the brothers are not in a boat but standing staunchly upright in the middle of John's Pass. Their feet are hovering just a few inches above the water. The apparitions are pale and scrawny, as if they are suffering from lack of food. Their clothes, the blue uniforms of the Yankee navy, are faded, tattered and torn. These figures are dripping with grease and mold. Worst of all, the sight of the brothers is always accompanied by an overwhelming stench of decaying human flesh.

In April of 2002, S.P.I.R.I.T.S. of St. Petersburg, a paranormal investigative group, came to John's Pass at 5:00 a.m. on the morning after the new moon hoping to see the brothers' specters for themselves.

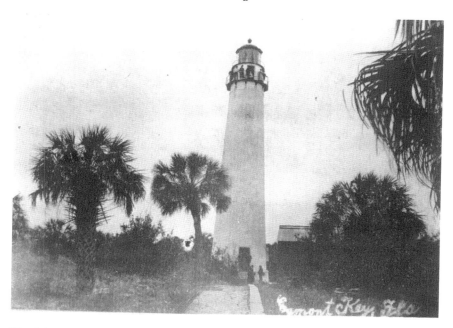

The lighthouse on Egmont Key. Built in 1848, it was standing here at the time the Whitehurst brothers were killed. *Courtesy of St. Petersburg Museum of History.*

Although they did not actually see the spirits, some of the photographs they took that early morning show orbs floating above the buildings along the waterfront.

Coincidentally, for nearly a century, locals have reported seeing orbs rising from the grave of Scott Whitehurst. They described them as "ghost lights." Witnesses said these lights drifted across Boca Ciega Bay and moved up to the old Whitehurst farms in what is now Seminole. Do these spirits return because they feel their former friends and neighbors betrayed them? Or are they perhaps paying a penance for their own betrayal of their native state? Perhaps these tortured souls are "living" proof that betrayal, like beauty, is in the eye of the beholder.

ELEANOR KEY

Today the area around John's Pass vibrates with activity. Shops and high-rise condominiums abound, and people and boats create a buzz of action nearly twenty-four hours a day. But five hundred years ago things

were totally different. This was once a quiet, green place inhabited by a small band of native people whose skin was browned by the sun and decorated with primitive tattoos. These people were the Tocobaga. And they had been here for hundreds, perhaps even thousands, of years before the Spanish Conquistadors set foot on this soil.

When the Spanish arrived they brought with them European diseases, which decimated the native population. Those that were not killed by the measles or smallpox were carried off as slaves to work in plantations and fields. Almost nothing remains of this ancient culture. In fact, Encyclopedia Britannica describes these people as extinct, although there are a few individuals alive today who still claim to have Tocobaga ancestry.

These natives left us two forms of evidence of their existence. The first is huge mounds of discarded shells from the seafood that they gathered and ate as the main staple of their diet. These mounds are known by archaeologists as "kitchen middens." Unfortunately, the contents of many of these mounds were used to pave early roads in Pinellas County. The other evidence of their existence is also in the form of mounds. Burial mounds.

Sometime in the late 1850s, two local pioneers, John A. Bethell and Anderson Wood, were hunting on Eleanor Key, which is a large mangrove island that can be seen just to the south of the boardwalk at John's Pass Village. They came across a small ridge, which they at first assumed was a natural ridge. Much to their surprise, they saw two human skulls and several small bones perched on top of the ridge.

After this unsettling discovery, their first thoughts were of treasure. They reasoned that if this was a Tocobaga burial mound, there might be gold and silver adornments hidden inside. They began to dig quickly and haphazardly, with no respect for either the archaeological significance of the site or the sacred nature of the mound to the ancient people. This act of desecration yielded no treasure of silver or gold. Instead they discovered three levels of skeletons, with the skulls facing toward the north and the feet toward the south, and many pieces of broken pottery.

Disappointed, and suddenly feeling afraid, the two young men quickly covered up most of the bones. However, they took with them one huge skull and jawbone, as well as two large thighbones. These bones indicated that the native people were of large stature. In fact, the skull and jawbone could easily fit over the heads of the young men. And the thighbones came nearly to the level of their waists. These stolen bones were eventually given to the Smithsonian in Washington, D.C. But since

the day of this unauthorized excavation, the spirits have been restless on Eleanor Key. In the hours between midnight and dawn, a ghostly mist and unusual light hangs low over the island. A green glow rises slowly over the center of the mangrove trees and then spreads out until it covers the entire top of the island. Sometimes, the sounds of Native American drums are heard. Flashes and balls of light with no apparent source have also been seen.

The island is now a bird sanctuary, and the intrusion of human beings is no longer allowed. Hopefully, as time passes, the spirits of the natives will find peace and rest again.

CAPTAIN HUBBARD

In October of 1929, a traveling carnival arrived in Pass-A-Grille to play a one-night stand. The carnival was owned by George and Anna Hubbard. Their plan was to entertain in the small Gulf beach town and then move on to their winter quarters in Miami. Unfortunately, the very day they set up their tents in Pass-A-Grille was "Black Tuesday," the day the American stock market crashed. George Hubbard reasoned that if people didn't have enough money to eat, they would not be spending money on traveling carnivals. So he sold everything that he could and purchased a small hotel in Pass-A-Grille. Like so many before them, George and Anna Hubbard became permanent Florida residents.

At the time they arrived, their young son, Wilson, was sixteen years old. He helped the family during those early days of the Great Depression by doing a lot of fishing. What the family didn't need for food he would sell. In just one year he had saved enough of his fishing money to buy five little rowboats and forty cane fishing poles. Thus began the career of one of the greatest fishing guides of the Gulf beaches.

Captain Wilson Hubbard ran his business from the Eighth Avenue pier in Pass-A-Grille until 1975 when he moved his boats up to John's Pass Village. In 1976 he opened the Friendly Fisherman, a seafood restaurant bearing the same name as one of his boats. According to his daughter Patricia, Wilson was also the first person in the area to start a "dolphin watch" boat ride. She said that at the time people told him he was crazy. "Nobody is going to pay to go out in a boat to see dolphin," people said. Of course, now there are dolphin sightseeing cruises making people smile up and down the Gulf beaches.

An undated view of early John's Pass Village. *Courtesy of St. Petersburg Museum of History.*

Wilson passed away in 1994. But his presence continues to be felt throughout John's Pass Village. It seems he likes to return to check on the legacy he left behind.

A portrait of the captain hangs on the wall outside the Friendly Fisherman. The image is not a frightening one. The captain looks kind and a bit mischievous. However, no matter where you stand, if you walk from one side of the portrait to the other, the eyes of the captain will follow you! Several people have claimed that the portrait has actually winked at them.

Inside the restaurant there is a small shelf near the service bar. When Wilson was alive this shelf was home to a bottle of rum, which he frequently used to spike his coffee. Of course since his death, there is no reason to keep rum on the shelf. Drinking glasses are now stored on the shelf. But, according to Wilson's daughter Kathleen, a few times a week those glasses rattle for no apparent reason. Often, one will fall off the shelf and break. Is it the Captain searching for his bottle of rum?

A former night manager by the name of Trent says that he had several encounters with Wilson Hubbard when he worked at the Friendly Fisherman. The most vivid one was very late one evening after the

restaurant had closed, and everyone except Trent had already gone home. At about 3:00 in the morning, Trent heard a slow, even, deliberate knocking coming from inside one of the walls. "Not fast and irregular like a pipe rattling," he said. "The kind of knocking that only a human hand could do." He decided to "just get out of there." But when he went to enter his exit code into the restaurant security system, the system flashed back that it could not set because "motion was detected" in the empty restaurant. Trent walked through the entire restaurant looking for the source of the motion. There was nothing and no one to be seen. Once again he tried to enter his code, and once again the message of "motion detected" flashed back at him. He decided at that point to just get out and lock the doors behind him.

The next morning when the day shift arrived, the alarm was correctly set. Could Captain Hubbard's ghost have felt bad about driving Trent away and set the alarm himself to protect his restaurant?

Renovation and remodeling often make ghosts more agitated. At the present time, the John's Pass Boardwalk and Hubbard's Marina are undergoing a full-scale reconstruction. And Captain Hubbard has been seen more frequently as a result. Besides his usual haunts (no pun intended), his image has been seen on his dolphin-watching boat, *The Sea Adventure*. One of the employees of the local gambling cruise ship has reported that on several evenings, when the cruise returned in the wee hours of the morning, she looked at the empty and locked *The Sea Adventure* and saw the shadowy image of Captain Hubbard standing at the wheel.

The image of the captain is easy to identify. He was quite tall and slender and usually had his gray hair tucked up under a sea captain's hat. He also always wore one red sock and one green sock, as a reflection of the port and starboard navigation lights on a boat. Kathleen told me that he wore those socks with his tuxedo when he walked her down the aisle. And his son Mark said, "We buried him wearing those socks."

PIRATE LEGENDS

JOHN GOMEZ

Every year the Tampa Bay area celebrates one particular pirate. A huge Mardi Gras style party is held in February, with the usual accompaniments of beads, revelry and the consumption of intoxicating

beverages. Supposedly this festival is to honor a legendary Spanish pirate by the name of José Gaspar. It is known as the Gasparilla Festival and Pirate Invasion, and it is one of the highlights of the year for folks who live in and around the city of Tampa. Gasparilla is a Spanish word that means "little Gaspar." Supposedly, this was the affectionate title given to the ruthless pirate captain by his men. Unfortunately, most historians agree that José Gaspar never existed. He is merely a legend. But that is certainly no reason to stop the party!

However, there are several very real pirates that called this area home over the years. And many of them have left their imprints on the area in the form of ghost stories. In fact, one of those real pirates was probably the man who "invented" the legend of José Gaspar. His name was John Gomez, and he was the founder of the tourist industry along the beaches near Tampa Bay. He was also not one to let the truth get in the way of a good story.

As he told it, he was born in 1778, possibly on the Portuguese island of Madeira. His family later moved to Spain, and then on to France. When he was just a teen he immigrated all by himself to South Carolina and then to St. Augustine. While in Florida he signed on a ship as a merchant seaman. However, once his ship was at sea, it was seized by pirates. But not just any pirates. This particular pirate ship was under the command of the infamous José Gaspar. Or at least that's the way Gomez told it.

Conveniently, Gomez always seemed to find himself at the important junctures in history. He claimed to have witnessed Napoleon Bonaparte's triumphal march into Madrid and to have been with Zachary Taylor at the Battle of Okeechobee on Christmas Day 1837. He also claimed that although he could neither read nor write in any language, he could fluently speak seven.

How much of this was true? Historians are not sure, but they believe that almost all of it was made up. Even Gomez's date of birth. If he were really born when he claimed, he would have been about 80 when he came to Florida and about 124 years old at the time of his death. One thing on which most historians agree is that he could not have been captured by José Gaspar. Because most (but not all) historians agree that there was no such person as José Gaspar, despite the annual Gasparilla Festival and Pirate Invasion.

Here are a few things we know are true. John Gomez arrived on the barrier island of Pass-A-Grille sometime in 1857. He cleaned out the old Spanish well that had been filled in when the waters from the Great Gale

of 1848 overran the island, providing fresh water. He built the first tourist amenities, which were little more than crude benches and tables. Then he began to bring people over from the mainland to enjoy the beaches. He used his own boat *The Red Jack* for that purpose.

At that time there were no hotels on Pass-A-Grille. Indeed there were not even any permanent structures, so these were just day trips. While this job was only a sideline for Gomez, who was working as a government boat pilot at the time, it became a very lucrative one.

John could tell a good story. Tourists would come with their picnic baskets and bathing costumes, swim in the surf, sun on the beaches and then listen to John's inventions for hours. His tales of the wild exploits of José Gaspar continued to grow in the telling. I'm sure old John would be very pleased with the Gasparilla Festival and Pirate Invasion in Tampa every year. He would get a really good laugh out of that!

Unfortunately for John, the Civil War put an end to his tourist activities. The Union navy captured Egmont Key, very near Pass-A-Grille, in 1861. and *The Red Jack* was out of business. Sadly, John Gomez decided to move himself and his famous stories farther south. He settled on Panther Key near Fort Meyers, but he often came to visit Pass-A-Grille to talk about old times for nearly the next forty years. On July 12, 1900, he was out fishing when he apparently became tangled in his own nets, fell overboard and drowned. By his request, he was buried near the beach of his beloved Panther Key. But tide and time wait for no man. No trace of his grave remains today.

However, if you walk the streets of Pass-A-Grille on balmy spring evenings, just after the moon has risen. You may experience the spirit of "the last of the pirates." While John Gomez is not seen, he is definitely heard. Witnesses have reported the sound of a deep male voice speaking or singing in the soft breezes of Pass-A-Grille. Although, the individual words cannot be distinguished, it's a good bet that John is up to his old tricks, telling stories that get wilder and wilder every time they are told.

Pierre LaBlanc

Another, more gruesome, tale involves the buried treasure of the famous pirate Jean Lafitte. History tells us that Jean Lafitte helped General Andrew Jackson defeat the British at the Battle of New Orleans during the War of 1812. For his assistance in the battle, the United States government issued an official pardon to him for his crimes of piracy. So for a few years, Jean Lafitte lived the life of an upstanding citizen.

However, he soon became bored with the honest life, and once again turned to plundering on the high seas. According to legend, Lafitte had buried a large share of treasure on an island or key near the Florida coast. While, it is true that no one knows for sure the exact location of that island, many believe it was along the Gulf beaches near Tampa Bay. Captain Lafitte left a trusted member of his band, Pierre LaBlanc, on the island to guard the treasure. To assist his mate in guarding the treasure, Lafitte gave him the gift of a large and beautiful palomino horse. Twice each day Pierre would mount that palomino and ride around the island, checking on the treasure.

Now, a palomino horse may be wonderful for guarding treasure, but they are not much company for one man alone on a barrier island. One day, LaBlanc came upon a man on the island hunting snakes. Apparently, LaBlanc had been on the island alone too long, for instead of running the stranger away as he should have, he struck up a conversation with the man and allowed him to remain. A few nights passed, and one evening, around their campfire, LaBlanc and the snake hunter decided to have a few drinks just before sundown. Somehow, the crafty snake hunter stayed sober while LaBlanc became quite inebriated. Drunkenly, he mounted his horse to make his nightly check of the treasure locations. The snake hunter surreptitiously followed him and marked the locations of all the treasure. When they returned to the warmth of their fire, the snake hunter simply waited for the drunken LaBlanc to pass out.

Seeing his opportunity, the snake hunter quietly crept out to one of the treasure locations and began to fill his pockets with gold and jewels and pieces of eight. However, LaBlanc woke up, and realizing what was happening, he tried to stop the would-be robber. Although LaBlanc was the larger, younger and stronger man, he was very drunk. The snake hunter took a machete and cut LaBlanc's head from his shoulders.

Quickly, the robber filled his pockets with jewels, jumped in his small boat and rowed away. But as he looked back, he saw the beautiful palomino horse standing at the water's edge. He swore to his dying day that on the back of the horse, shaking his saber in the air, was the headless corpse of Pierre LaBlanc.

BLACKBEARD

One of the most famous real pirates of all time was Blackbeard. An Englishman born in the late seventeenth century, his real name was Edward Teach and he began his career as a relatively honest privateer. A

privateer was a ship's captain who was actually licensed by one particular country to prey on the ships of other countries. Of course, that captain would also have to share his booty with the country that held that license, which in Edward's case was England. However, he soon decided that the life of a pirate would be more profitable. After all, he reasoned, as a full-fledged pirate he could prey on all ships, including the English, and he would never have to share his plunder with anyone. He named his boat the *Queen Anne's Revenge* and began to ravage merchant ships from any country wherever he found them. He began this reign of terror by attacking boats in the Florida channel near Tampa Bay.

Edward Teach was six feet, four inches, which was extremely tall for the early 1700s. He had a bushy, curly, black beard and curly, black hair, which were the source of his fearsome nickname. Blackbeard had a habit of inserting slow-burning materials (like cannon fuses or Spanish moss that he had soaked in saltpeter) into his hair and beard and setting these materials alight before entering a battle. He must have looked like the devil incarnate, a giant of a man, armed to the teeth and flaming and smoking.

Blackbeard also had an interesting matrimonial history. He may have been married as many as fourteen different times. Part of the reason for his high divorce rate was that he had an unseemly habit of asking his wives to dance for him. This doesn't sound so bad, even for the early eighteenth century, until one learns that if his wife wasn't dancing high enough or fast enough to suit him, he would take out his pistol and start shooting at her feet until her dance was more suitable to his taste. Charming husband, indeed!

Just before his last battle he was asked by one of his crew members if anyone other than himself knew where his treasure was buried. The mate was justifiably concerned that if the captain should die in battle, the treasure would be lost. Blackbeard replied that nobody but himself and the devil knew where the treasure was buried, and "the longest liver should take it all." By this he meant whoever lived the longest, the devil or himself. The mates all swore that this statement was an evil omen. It was as if Blackbeard was making a bet with the devil as to who would live the longest. And that is not a very good bet. The superstitious sailors all knew that none of them would outlive "old Lucifer" himself.

Sure enough, in the very next battle, which took place off the coast of North Carolina on November 22, 1718, Blackbeard's luck ran out. It took three gunshot wounds and six stab wounds to bring him down. But finally,

he lay dead on the deck of his ship. The commander of the English fleet ordered that the corpse be decapitated and the head hung from the bowsprit of the ship. After this was done, the commander ordered that the headless body be dumped into the ocean. All the witnesses, both the British seamen and the captured pirates, claimed that when the dead body hit the water it began to swim. They watched it swim seven times around the ship, as if it was looking for its head, before finally giving up and slowly sinking beneath the waves.

According to some contemporary accounts, the British ship set sail with the head of Edward Teach still attached to the bowsprit. And on the day that many of his mates were sent to their deaths on the gallows, the head was exhibited on a pike, as a warning to other would-be pirates.

There is some debate as to what eventually happened to the skull of the famous pirate. Some claim that it was actually made into a drinking bowl, which made the rounds of the taverns and alehouses of Williamsburg, Virginia. The Peabody-Essex Museum in Salem, Massachusetts, claims to be currently in possession of the famous head. After the passage of all these years, it is difficult to know for certain one way or the other. However, the moral of this tale is certain. Never make a bet with the devil!

The Ghosts of St. Pete Beach

The city of St. Pete Beach runs along the barrier islands of Tampa Bay, with 4.5 miles of beach along the Gulf of Mexico. There are just over ten thousand permanent residents, but during tourist season, the population nearly doubles with snowbirds and visitors.

St. Pete Beach is really a melding of four smaller towns, Don CeSar Place, Belle Vista, St. Petersburg Beach and Pass-A-Grille. This merger occurred in July of 1957. And please don't refer to the town as St. Petersburg Beach! The name was officially made St. Pete Beach in 1994. This was done to firmly differentiate the small beach community from its larger sister city, St. Petersburg.

COMFORT AND JOY

The southernmost point of the barrier islands of Tampa Bay was once the village of Pass-A-Grille. The area still likes to keep its historic identity intact, even though it is now part of the larger entity of St. Pete Beach. It gets the rather odd name from its early history. Most historians believe the name comes from the French phrase *la passe aux grilleurs*, or "passageway of the grillers." The phrase is said to refer to the fact that French (and most likely some Spanish) fishermen used to stop here to salt and grill their fish.

West Indian pirates introduced the technique of grilling fish over an open fire on a latticework of green sticks during the late 1700s. The fish, or any other product, that was cooked in this manner was called "boucan," which is another French word. And those who used this

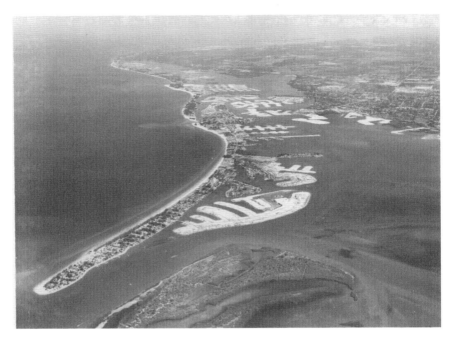

St. Pete Beach. The very southern tip is Pass-A-Grille. *Courtesy of St. Petersburg Museum of History.*

method of cooking were referred to as "boucaniers." Of course, that became the origin of the term "buccaneers," used to refer to pirates of the Gulf of Mexico and the Caribbean Sea, not to mention Tampa Bay's professional football team.

Pass-A-Grille contains some extremely desirable real estate. For about a mile, it is only one block wide, with the Florida Intracoastal Waterway on one side and the Gulf of Mexico on the other. No matter where you look, there is water.

Today Pass-A-Grille is a part of the city of St. Pete Beach. Many residents of Pass-A-Grille were not happy when the merger was proposed in 1957. They called themselves "Grillers" and organized a strong opposition, but their efforts were to no avail. On July 9 of that year, the two towns became one. But Pass-A-Grille still retains its own distinctive character and history. The area from First Avenue to Twelfth Avenue, from the Gulf side to the bay side, has been designated as a National Historic District.

In the heart of this historic district stands a charming two-story home at 808 Pass-A-Grille Way looking out over the serenity of the Intracoastal

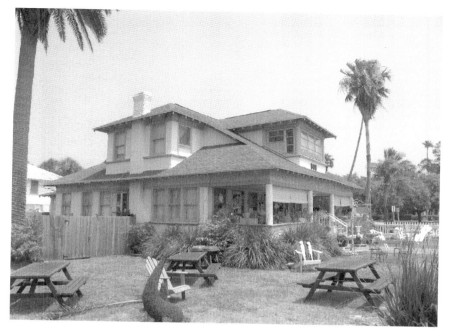

Comfort and Joy, the former home of Judge Swerdtfeger. *Photograph by the author.*

Waterway. It was built in 1911 for Judge L.C. Swerdtfeger, a retired bank president from Illinois. On February 2 of that same year, the judge presided over the town meeting where the residents (or at least all of the male property owners) unanimously voted to incorporate the town. The following June, by vote of the Florida legislature, this area became the first official town along the Tampa Bay area beaches.

Judge Swerdtfeger was appointed interim commissioner of the new town, and he planned to run for official election to the same post. But he died on Thanksgiving Day, November 26, 1911, two months before the first public election. The cause of the judge's death is not known for certain, but because he was a diabetic, it was most likely a heart attack or a stroke.

Ghosts often return to haunt certain places because they feel that they have "unfinished business." In other words, there were things that they wanted to accomplish in their lives, but death took them away too soon. Perhaps the judge feels that way about becoming the commissioner of Pass-A-Grille.

At one time there was a tearoom on the porch of the judge's former house. Visitors to the tearoom would often describe a kindly looking

elderly gentleman sitting at one of the nearby tables, quietly sipping a cup of tea. He was quite polite and would nod and smile. However, if the customers looked away for a moment, when they looked back, the man was gone. The same gentleman has been seen peering out from the windows in the second-story dormer, and his footsteps have been heard across the porch when no one was in sight.

The current owners are Angie and MaryAnn. They purchased the home in April of 2005 for two reasons. First, they were concerned that someone else would purchase the property to build either condominiums or a huge "McMansion." They hoped to preserve the character of Pass-A-Grille and the historic house itself. Second, they wanted a place where they could live and start a gourmet food business. The result is a lovely store now known as Comfort and Joy.

Almost as soon as they moved in, they had their first encounter with the judge. MaryAnn and Angie have two dogs, a large white standard poodle named George and a smaller dog named Remey. Once, when they had to be away for a few days, they asked MaryAnn's brother to stop in and care for the dogs. While the brother was in the house, he distinctly heard the footsteps of someone moving through the house. Of course, there was no one to be seen. He was not too happy with his sister for not warning him about the possibility of ghostly visitors in the house.

Another evening, Angie was sitting on her bed, located in the front of the house on the second floor, with both dogs at her feet. Normally, George and Remey would be alert and barking if there was an unusual noise of any kind. However, they did not even stir as Angie heard the sound of footsteps. She described the sound as "a man wearing leather dress shoes" walking across the first floor, climbing the stairs to the second floor and then walking down the hallway to the room that was once the judge's office. After a few moments of silence, the footsteps started again, leaving the office, walking down the second floor hallway, descending the steps, treading through the kitchen and exiting out the back door. The problem with exiting through the back door is that Angie and MaryAnn never use that door. In fact they have shelving in front of that door, piled high with pots and pans and cooking utensils. No living being could have left the house by that back door without making an incredible racket. And yet, no sound other than the footsteps was heard.

Lately, the two ladies have seen another spirit in the house, a little girl in a white dress. MaryAnn was the first to see her in September of 2005. Early one morning, when it was still dark, MaryAnn rose early to let the

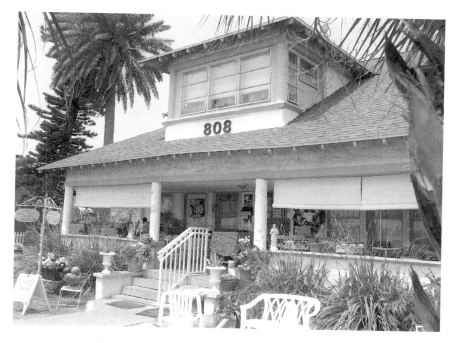

Another view of Comfort and Joy. *Photograph by the author.*

dogs outside. She was being very quiet because they had a guest in the house, a friend of theirs named Lisa. Out of the corner of her eye, she glimpsed a small blonde figure wearing a flowing white nightdress who was standing underneath an archway connecting two of the rooms. As MaryAnn turned to look, the figure whizzed up the stairs. MaryAnn was afraid that she had awakened their guest. But when she went to check on Lisa, she was still in bed, sound asleep, and wearing flannel pajamas. The figure she had seen could not have been Lisa!

Since that time, both MaryAnn and Angie have gotten a closer look at their mysterious visitor on several occasions. She is a girl around ten years old or possibly in her early teens, and she makes her presence known even when she is not seen. This young lady, whoever she may be, seems to have a fondness for moving the jars of homemade food items that line the shelves of the shop. Sometimes she chooses to move them right in front of the customers. On one occasion, a woman who had been a difficult and cantankerous customer was standing next to the shelves, examining the various items, when one of the jars lifted off the shelf without any visible means of support, hovered in the air for a moment and then fell to the

floor. The woman was quite defensive. "I did not touch that jar," she said. Angie assured her that it wasn't a problem. After all, it was probably just the judge or the little girl playing a prank. MaryAnn said that the woman left in quite a rush. In fact, she doubted that the woman's feet touched more than one step on the front staircase as she made her way back to the sidewalk. Perhaps the little blonde girl was not happy about such an unpleasant woman in the store.

MaryAnn and Angie have now retired from running Comfort and Joy. Their former home is now an antique store. One wonders what the judge and the little girl think of that!

SILAS DENT

In 1900, a man who was to become legendary in the Tampa Bay area came to Pass-A-Grille. His name was Silas Dent. He started off normally enough. He and his family ran a small dairy farm on Cabbage Key, which is just across the Florida Intracoastal Waterway from Pass-A-Grille. The vegetation proved to be spectacularly unsuitable for the grazing of dairy cattle, so the Dents gave up on their little dairy after just a few years and sold the property. Silas tried to live in town, but just couldn't adjust to city life. So he asked for permission from the new landowners to move back to Cabbage Key. His request was granted and he lived alone in a little hut with a thatched roof for the rest of his life. He became known as the "Happy Hermit of Cabbage Key."

He had no electricity, and his idea of running water was to take a bucket and run. He made do with a kerosene lantern and a hand pump on his old well. Silas fished, hunted and gathered shellfish for his food. The few things that required "cash money" were paid for with money earned by selling "skeeter swatters" that he made out of palm fronds and sold to the tourists in Pass-A-Grille for a few pennies. The large number of mosquitoes that inhabited Pass-A-Grille in the early days was a guarantee that there would always be a demand for his product.

His island was not exactly paradise. Besides the mosquitoes, there were the ubiquitous no-see-ums, palmetto bugs and other insects. And then there were the rats and the snakes. Silas actually liked the snakes. They kept the rat population in check.

Silas was not always alone. Although, he enjoyed his solitude, he would welcome visitors on those rare occasions when they found their

way to Cabbage Key. In fact, for five years he even had a neighbor of sorts. In 1941, a man named Sid Hobart found his way to the island after the death of his wife and children in a tragic fire. Silas allowed Sid to stay. Sid earned his keep on Cabbage Key by gathering shells along the beaches and selling them. He became known as "Sid the Shellman." You could not really describe the two men as friends. Silas's temperament didn't exactly allow for friendship. But they coexisted peacefully until one fateful day in 1946.

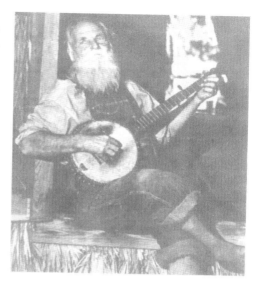

Silas Dent, the "Happy Hermit of Cabbage Key." *Courtesy of St. Petersburg Museum of History.*

The two men were coming across the bay from Cabbage Key to Pass-A-Grille to sell their shells and swatters when a high-powered motorboat broadsided their small skiff. Silas and Sid were both thrown into the water by the impact. Sid was struck by the propeller of the speeding boat. Silas was a strong swimmer, and he held on to his friend in the water until help arrived. But it was to no avail. Sid had been nearly cut in half by the whirling blades and was beyond any help this earth could offer.

Silas never quite got over the loss of his neighbor. In fact, a few years later, his niece was able to persuade him to leave the island and move into her home on the mainland. The very first evening, his thoughtful niece prepared a nice warm bath for her uncle. But he slipped and fell getting into the bathtub and fractured five ribs. Silas again moved back to Cabbage Key. "Civilization is too dangerous!" he said.

Once again alone, Silas would row over to Pass-A-Grille once or twice a week. His rowing style was unique. Instead of facing the rear of the boat and pulling on the oars, he would face the bow and push. "Never much worried 'bout where I been," he once quipped, "more 'bout where I'se goin'."

It was December 24, 1950, when Silas passed away. Christmas was a special time for Silas. Strange as it seems for a hermit, Silas would often

play Santa Claus for the Pass-A-Grille children. So, it is fitting that he left this world on Christmas Eve. Or did he?

Children, both those who visit Pass-A-Grille and those who live there, have reported seeing a man rowing across the bay in an unusual manner. They report that this man is facing forward in his small rowboat and pushing on the oars. They have also described him as resembling Santa Claus. These children are much too young to remember Silas Dent. Furthermore, most of them are visitors from other parts of the country. They would have no way of knowing the habits and appearance of this hermit from long ago. They only report what they see.

THE CASTLE HOTEL

At 401 Gulf Way sits a small hotel. This modest two-story building of cream-colored stone was named the Castle Hotel when it was built in 1906, and it has kept that name to this day. Even after more than one hundred years, it retains the character of an "old Florida" hotel. There are no frills—no televisions or telephones in the rooms. But it still offers a magnificent view of the sunsets over the Gulf of Mexico from its front porch. And it offers the most reasonable rates on the beach.

Just as in its early days, the Castle Hotel is only open for "the season," from January through April. And it has a few year-round residents who occupy small apartments. One larger apartment in the back serves as the home of the owners, Bob and Geri Ruhlman, when they are in town.

The Ruhlmans purchased the Castle Hotel in 1972 and have kept it in their family for over a quarter of a century. This is no easy task, as the land underneath the hotel is quite valuable and the taxes and insurance costs are very high. Bob says he hopes the hotel will stand there for many years to come, even though he has had several offers for the property. "They basically told me to name my price," he says.

From 1972 to 2002, a frequent visitor to the Castle Hotel was, appropriately enough, a queen. Marian Bergeron was crowned Miss America in 1933. At only fifteen years old, she was the youngest Miss America ever, and because there was no pageant in 1934, she held the title for two years. She was also Bob Ruhlman's mother.

According to the official Miss America website, she was one of the best loved of all the contest winners. Over the years, she was always helpful and sweet, and ever willing to assist the other members of the small club

The Ghosts of St. Pete Beach

The Castle Hotel. Room number 5 encompasses the front of the building on the second floor. *Photograph by the author.*

of Miss America winners. Unfortunately, she died in 2002 of a rare form of leukemia, leaving behind her three children, grandchildren and many, many friends.

Bob says his mother absolutely loved the Castle Hotel. During the last twenty years of her life, she would visit whenever she could and even lived there for a time. And Bob is certain that she continues to visit. He often feels her calm and comforting presence come over him. He says he has also heard unexplained noises on the second floor, and he believes it is his mother checking on her family and her beloved home by the sea.

Another legend of the hotel is from the very early days of its existence. The story is that of a young couple who came to stay at the Castle Hotel for their honeymoon in 1921. They checked into room number 5, which was, and still is, the hotel's best room. It is on the second floor and encompasses the entire front of the hotel. It is the only room that offers a totally unobstructed view of the Gulf. Just a few days after their arrival, the young bride was drowned while swimming in the warm waters of the Gulf.

Travel was more difficult in those days. You couldn't just hop a plane for home, even in the direst of circumstances. The poor young groom had to spend one horrible night with the body of his beloved lying on the

bed in their room, awaiting transport by railroad the following morning. Understandably, he found himself unable to sleep, so he paced the floor all night. His footsteps could be heard in the lobby below.

Although, we do not know the ultimate fate of the young man, it is likely that he himself has now passed on. Yet his spirit returns to the site of his greatest sorrow. Guests have told us that at exactly 11:00 p.m., anyone in the lobby will hear the sound of his pacing footsteps above their heads. These sounds continue until midnight and then abruptly stop.

Despite the many offers, the Ruhlman family has no immediate plans to sell the hotel. "I know what will happen," said Bob. "They would just tear it down." So let us hope this little bit of long ago will be around for many more years.

The Hurricane Restaurant

At the corner of Gulf Way and Tenth Avenue stands a three-story restaurant built in the "Key West style" of architecture. It is known as the Hurricane and offers local specialty foods, tropical drinks and expansive views. One of the waiters at the Hurricane told us about his ghostly experiences. Although he has no idea who is actually haunting the place, he is certain that there is at least one spirit there that does not come from behind the bar.

Late one night, he was the last person out of the restaurant. He turned off all the lights and locked the door. As he was walking to his car he happened to turn and take one last look at the Hurricane. To his surprise he distinctly saw a candle burning in a second floor window. He returned to the building, unlocked the door and walked up the back stairs to the second floor. The room was completely empty. There was no candle or any other light source.

Puzzled and thinking perhaps what he had seen was just a trick of light and reflection, he once again left the restaurant and locked the door behind him. However, when he walked away he looked up at the second floor. Once again, he was sure he could see a candle burning. This time, when he returned to the second floor there was a candle burning in the room, which had been totally dark just a few minutes before. The building was empty and had been locked. How did that candle come to be burning?

The waiter blew out the candle and said, "Hey, I'm tired and I want to go home." This time when he left the building, all the windows were dark. So apparently, ghosts can be reasonable if they are asked politely!

Don CeSar

Just north of Pass-A-Grille there was another small town known as Don CeSar. And like its neighbor to the south, it became part of the larger town of St. Pete Beach in 1957. The most distinct building in this area is a grand pink hotel resembling a Moorish castle that sits along the expansive beach of the Gulf of Mexico.

Often, some places are believed to be haunted because a violent or premature death occurred there. Other times, a haunting is precipitated by a traumatic event. Neither of these is true in the case of the Don CeSar. Yes, many people believe it is haunted. But it is haunted by the spirits of those who found happiness and rest within its walls. We often refer to ghosts as "restless spirits," but those who walk the halls and beaches of the famous pink palace are perfectly happy to remain in this splendid hotel, enjoying its many amenities in peace.

The Don CeSar was built in 1928 by real estate developer Thomas Rowe. He spent $100,000 to purchase eighty acres on a barrier island known as Long Key. This was an unheard of sum for that day and age, but the same property would be worth many millions today. Rowe called his little empire, Don CeSar Place. He divided some of the land into lots to be sold for homes. He saved one narrow strip of land along the beach to build a hotel.

The original plans were for a T-shaped, six-story building with 110 rooms, but by the time it was completed two more wings had been added, giving the hotel a total of 300 rooms, and bringing the project in at $1,500,000.00, or 300 percent over its original budget.

Bear in mind that there were no other grand hotels on the Gulf beaches at that time (both the Belleview Biltmore and the Vinoy had been built by this time, but neither of them sits directly on the sands of the beach). Most people believed that a hotel on this scale could not be built on the soft and shifting sand. Thomas Rowe's architect, Henry du Pont, invented a floating concrete platform to form the base of the hotel. This platform has not sunk one inch since the Don CeSar was built.

The architecture has a Spanish/Moorish theme and was based on the Royal Hawaiian in Waikiki. The pink color was custom mixed paint by the DuPont Company. To this day that paint color is called Don CeSar Pink. The hotel is repainted every five years, and it takes over nine months to spread over twelve thousand gallons of paint.

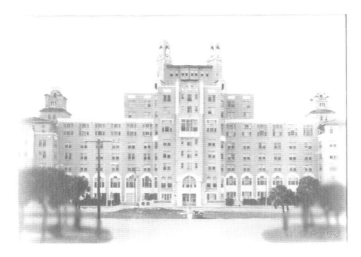

The Don CeSar circa 1915. *Courtesy Don CeSar Beach Resort.*

The gala opening was held on January 16, 1928. Fifteen hundred people arrived in their best finery for the party. They dined on elegant cuisine and danced the night away to a five-piece orchestra. The astronomical price tag for attendance at this event was $2.50.

Thomas Rowe was born in Boston, Massachusetts, in 1872. He was orphaned at the age of four and was sent to England to be raised by his grandfather. When he was a young man, he went to London to be educated. Sometime in the 1890s, he attended a performance of the light opera *Maritana*. He immediately fell hopelessly in love with the leading lady, a young Spanish soprano of great beauty. She played the title character in the opera, Maritana, a gypsy dancer.

Her name was Lucinda and she had long, dark, curly hair and beautiful dark eyes. Thomas Rowe went to every performance of the opera. Eventually, he managed to meet the leading lady and win her love in return. However, her parents forbade her to see Thomas. History does not tell us why. Perhaps they hoped for a better match for their daughter. Perhaps they wanted to preserve her career as an opera singer.

But true love is not so easily deterred. Thomas and Lucinda began to meet each evening after the opera performances near a graceful fountain in an open-air courtyard. They called this place their secret garden. Lucinda would come directly from the theatre, still dressed in her gypsy costume, with her long hair flowing. He would call her by the name of her character, Maritana, and she called him Don CeSar, the name of the opera's leading man.

The Ghosts of St. Pete Beach

During these clandestine meetings they formed a desperate plan. The night that the opera closed, they would meet at the fountain and sail off to America to begin a new life together. When the night arrived, Thomas raced to the fountain and waited…and waited…and waited. Lucinda did not come. Desperate, he ran to the theatre and found it empty, dark and deserted. With his heart breaking he searched for his love. He later learned that her parents had spirited her away to their country home. He never saw Lucinda again. At least not in this lifetime.

Thomas Rowe came to America alone. He did marry, but was very unhappy in that marriage. He wrote many letters to Lucinda, but they were returned unopened. One day in the early 1900s, he received a note in the mail accompanied by an obituary from a London newspaper. His beloved Lucinda was dead.

The note, written by Lucinda just before her death, read:

> *Tom, my beloved Don CeSar. Father promised he will deliver you my message. Forgive them both as I have. Never would I despair. Nor could I forsake you. We found each other before and shall again. This life is only an intermediate. I leave it without regret and travel to a place where the swing of the pendulum does not bring pain. Time is infinite. I wait for you by our fountain…to share our timeless love, our destiny is time. Forever, Maritana.*

Thomas Rowe never fell in love again.

In the 1920s, Mr. Rowe moved to Florida (without his wife) and made a fortune in real estate investments. He decided to give a gift to the state of Florida, a beautiful pink palace to be built along the Gulf beach. He also saw that palace as a monument to his long lost love Lucinda. He named all the streets on his eighty acres after characters in the opera *Maritana*, and the hotel itself he named after the leading man in the story, the name his beloved called him, Don CeSar.

For the first few years, it was only open in January and February, (there was no air conditioning in those days, so few people wanted to visit Florida in the warmer months), but the Don CeSar soon became the place to stay in Florida. The famous and the infamous came to rest in the palatial rooms and walk the soft, white, sandy beaches.

When the hotel first opened, Thomas Rowe lived in one of the penthouse suites, but as he grew older and his health deteriorated, he moved into a suite just behind the front desk. He wanted to stay close to

the management of his treasured hotel. In 1940, while standing in the lobby of the hotel, he fell to his knees clutching his chest. He died of a heart attack a few minutes later in what is now room 101.

Since the death of Thomas Rowe, many say that he has never left the Don CeSar. He has been seen walking the halls in his trademark white suit and Panama hat. And he is not always alone. Often he is accompanied by a dark-haired, dark-eyed beauty in a gypsy peasant dress. They walk hand in hand, deeply in love. Thomas has found his Lucinda again, so it appears, just as she predicted in her dying message to him.

The first floor hallway, outside the room where Thomas died, has a particularly eerie feeling. Even visitors to the hotel who have not yet heard the tragic story of Thomas and Lucinda have reported feeling a chill emanating from the hallway. One guest even said that the walls appeared to be moving in and out slightly, as if the hallway were actually breathing.

Thomas Rowe was an asthmatic. He smoked menthol cigarettes "for his health." I doubt you'd get a physician to go along with that remedy today. Of course, since Florida has banned smoking in public buildings, the Don CeSar is now smoke free. Yet since the day of his death, members of the staff have reported the strong smell of menthol cigarettes in this corridor.

Also, several guests have reported that when they are walking toward the mirror at the end of the hallway, they see the reflection of someone walking behind them. But when they turn to speak to that person, there is no one there. One young woman swore she saw a small girl in a pink dress reflected in the mirror. The girl appeared to be walking right behind her. But when the young woman quickly turned around, there was no one at all in the hallway.

One of the hotel's former executives had a direct experience with Thomas and Lucinda. He was the only one who held the key to his current office in the executive suite, which was on the ground level on the south side of the building. One morning he arrived at the office very early. Everything was quiet, but as he got ready to put his key into the lock of the office door, he heard voices coming from inside. Two people were having a quiet conversation, a man and a woman. The conservation sounded intimate, as though two longtime lovers were speaking to each other of their love. The moment he turned the key in the lock, the voices ceased. With a trembling hand he opened the door. He later said, "I actually heard them leave. I could hear every step she made. I could even hear the crinoline on her skirt rustling. Every pore on my body had the goose bumps. It was bizarre." When he walked into his office, it was totally empty. This experience left the man so shaken that people kept asking him for the rest of the day if he

was all right. When he tried to explain what had happened to him, all he could do was stutter out his story.

At the time of Rowe's death, he had intended to turn over ownership of the hotel to his faithful employees who had stood by him over the lean years as well as the good ones. He made out his will as he lay dying. But the nurses in attendance refused to act as witnesses, and after his death, the will was ruled invalid. Ownership of the hotel went to Rowe's estranged wife, Mary. She was not a big fan of the Don CeSar. After all, it was a monument to the great love of her husband's life. And that great love wasn't her!

According to one publication, Mary was looking for any excuse to get rid of the hotel, so she turned the management of the Don CeSar over to her attorney Frank Harris. He managed to keep the Don afloat for one more season, January and February of 1941. But on December 7, 1941, all that changed. Not just for the Don, but for all the hotels and tourist attractions in Florida. With the bombing of Pearl Harbor and the beginning of World War II, cancellations poured in. Rubber for tires and gasoline for automobiles were scarce, and many people were actually afraid to travel. Besides, the huge pink hotel right on the Gulf of Mexico seemed like an excellent target for enemy submarines. When the Don CeSar closed for the end of the 1942 season, there were no expectations that it would ever reopen.

Frank Harris began negotiations to sell the building to the navy as officers' quarters. But the army heard about the navy's interest and managed to acquire the Don CeSar for unpaid back taxes in the amount of $440,000, less than a third of what it cost to build back in 1928. The Don became an army hospital in December of 1942. The elegant penthouse suites were turned into operating rooms. The morgue was on the ground level. The service elevator at the end of that first floor corridor was used to bring dead bodies down from the upper floors to the morgue, which perhaps also contributes to the eerie feeling of the hallway.

There have also been several reports of a man in a wheelchair sitting alone on the beach in the early morning hours, looking out over the waters of the Gulf of Mexico. This story has been repeated many times by hotel staff as well as hotel guests. If anyone approaches this figure, he simply disappears. Could this be the spirit of one of the army hospital patients? This is a reasonable explanation, as recuperating patients were often brought out to the beach by orderlies in the early morning hours. But there is also one other possible explanation. The Don CeSar has a beautiful presidential suite. It is on the level below the penthouses with

windows overlooking the Gulf. Nearly every president of the United States has stayed here during the years the Don has been a hotel, including Franklin Delano Roosevelt. Could the man in the wheelchair be the late Depression-era president? Mr. Roosevelt was a polio victim and needed a wheelchair, but he did not like the public to see him in that chair. So, it would make sense that he would come to the beach in the early morning hours and disappear when people approached.

When the hotel first opened there was only one kitchen in the entire Don CeSar. All of the meals were prepared there for every restaurant in the place, as well as room service. Customers could order a meal and have it brought to them on the beach for the princely sum of twenty-five cents. In fact, the other grand hotels of the area, the Belleview Biltmore and the Vinoy (both of which are also haunted), would send their customers down to the Don for the day just to enjoy the beach and the twenty-five-cent lunches.

Today, that kitchen is the site of hauntings from the army hospital era. Frank, one of the night chefs, described an incident just a few years ago. A big, strapping guy, six feet, two inches tall and 250 pounds, Frank was afraid of nothing. But one night he received a very late room service order for a hamburger and salad. When he tried to enter the food cooler, he saw a woman peering back at him from the other side of the glass on the door. She was dressed in the white uniform of a nurse, white cap and all! He was so frightened by this apparition that he refused to enter the cooler to get the food. Hotel security was summoned to check out the kitchen, but they found nothing. By the time Frank finally summoned up the courage to enter the food cooler, so much time had elapsed that the hotel had to give their hungry guest her food for free.

On another occasion, six employees were all working in the kitchen area when suddenly a huge racket began to emanate from the walk-in cooler. When the loud noises finally ceased, the startled employees opened the cooler, only to find that a lot of food was plastered on the door and on the floor. It was as if an unseen hand had been flinging food from the back of the cooler to the front. Unsettling, to say the least!

Either the above mentioned nurse gets around a lot, or there is a different nurse haunting these halls. A massage therapist doing a treatment in one of the therapy rooms was quite startled to see a woman with dark, wavy hair in a 1940s-style nurses uniform and cap. Before he could say anything, his client sat bolt upright. She seemed very upset. She said, "Did you see something in the mirror?" Then they both said at the same time, "A nurse!"

The Ghosts of St. Pete Beach

During the days of the army hospital the Don CeSar was much less grand. The original interior décor was stripped away. Everything was painted "government green." Furniture and fixtures were all hauled away. Perhaps the greatest loss was Lucinda's fountain in the lobby. It was ripped out and destroyed. However, on the fifth floor the replica of the original fountain in London was recreated. This is the spot where the couple is most frequently seen together.

All of the World War II patients were sent home by the end of 1945, although the Veteran's Administration (VA) continued to operate out of the building. Imagine a ten-story building in Florida in mid-August with no air conditioning! One by one the offices were moved elsewhere. By 1969, all VA and federal government offices were gone. The grand pink lady stood empty and deserted. Thomas Rowe's dream of a grand beach hotel seemed to be dead.

The inevitable began to happen. Windows were broken. Graffiti was painted on the walls. The famous Don CeSar pink paint was peeling away from the exterior walls. Vagrants broke in. What was once the most magnificent sight on St. Pete Beach became an eyesore. Instead of the pink palace, it became the pink elephant.

In the early 1970s there was a movement to tear down the hotel, with no respect for its historic significance. In the defense of those who advocated the Don's destruction, in the 1970s when people looked back at the '20s and '30s they didn't see "historic," they just saw "old." Now with the additional years of perspective, we see history.

A small group of local citizens, headed by a local historian named June Hurley Young, organized into a "Save the Don" committee. They were able to find a buyer for the hotel and restoration began in 1971. The Don CeSar reopened in 1973. Once again the pink palace reigns over St. Pete Beach.

During the restoration project in 1973, the new hotel manager decided he would introduce himself to the construction crew. One member of the crew got a puzzled look on his face and asked, "If you are the manager, who is the man in the white suit who oversees us?" Thomas Rowe must have been looking after the changes in his hotel.

He has also been seen walking along the beach. Once, a new employee, Lisa, was showing her husband around the grounds of the Don. She noticed a man in a white suit walking along the beach and remarked to her husband that the poor man must be so uncomfortably warm in that suit in the hot summer sun. Her husband replied, "What man?" The apparition had disappeared. This new employee knew nothing about

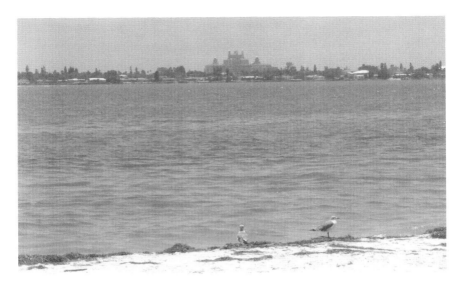

The Don CeSar as viewed from across Boca Ciega Bay. *Photograph by the author.*

the legend of Thomas Rowe, and yet she described him exactly as many others who have sighted him over the years.

The first hotel restaurant was the King Charles Room, which is located on the fifth floor. Originally it was the only restaurant in the hotel. It is now a ballroom, but you can still eat there if you like. They offer the largest and best Sunday brunch on the beach, with over 180 items. But in the late twenties and early thirties, it was where the elegant guests would dine, dressed in their formal attire. But they weren't drinking martinis. Thomas Rowe was against alcohol consumption. And of course, when the hotel was built, Prohibition was still in effect. Even after the repeal of Prohibition, there was only one bar in the Don CeSar for as long as Thomas Rowe was alive.

Both guests and staff have reported sightings of an apparition in the area near the King Charles Room. They describe a "glowing couple" dressed in the style of the 1930s. They are holding hands as they stroll along, gazing at one another, and their eyes are full of love. Some believe this couple is Mr. Rowe and Lucinda. But this is unlikely, as the description of this Jazz Age couple is very different from the dark-haired Spanish beauty and the man in the Panama hat. Could it be that another pair of star-crossed lovers walks those halls?

The Ghosts of St. Pete Beach

Francis Scott Key Fitzgerald was born in St. Paul, Minnesota, in 1896. He was named after his second cousin, three times removed, who was the man who wrote the lyrics to "The Star-Spangled Banner." As a young man he journeyed to Alabama where he met a lovely, spirited southern belle by the name of Zelda Sayre. The two fell deeply in love and became engaged. But Zelda's parents thought of young Fitzgerald as a totally unsuitable match for their pampered, sheltered daughter. They convinced her that he would "never amount to anything," and she broke off the engagement.

Despondent, Fitzgerald moved back to St. Paul and moved into his parents' town home (every parent's nightmare)! He moved into a third-floor bedroom and stayed there, hardly ever coming down. His mother brought him sandwiches and Coca-Cola, and helped to keep his many friends from causing any distraction. During this period of isolation, he completed work on a novel, which he called *This Side of Paradise.*

When he submitted the novel to Scribner's, it was immediately accepted for publication. The author's name appeared on the cover as F. Scott Fitzgerald. *This Side of Paradise* was a critical and financial success. Zelda's parents relented, and the couple was wed. Their wild and free lifestyle, financed by Scott's literary success, made them the darlings of the Jazz Age. They traveled all over the world, held and attended many wild parties and drank to excess. They spent their money much faster than they earned it.

In early January 1932, probably still hung over from New Year's celebrations, Scott and Zelda checked into the Don CeSar intending to stay the full season. They both planned to work on their novels. Scott had been working on a fourth novel for several years. It would eventually be published under the title *Tender is the Night*, but not until 1934. Zelda had never been published, but she had aspirations. They had the best of intentions, but they were easily distracted by sunshine, beaches and especially booze. Their famous contemporary, Ernest Hemingway, wrote about his friends, "Zelda was jealous of Scott's work and as soon as he was working well, Zelda would begin complaining about how bored she was and get him off to another drunken party." So, they didn't work, but they certainly played. Toward the end of January, this idyllic interlude came to an abrupt end. Zelda developed an unexplained rash, which refused to go away and began to spread. Physicians were consulted, but to no avail. Unfortunately, the Fitzgeralds had already learned that these bouts of eczema were precursors to psychotic episodes for Zelda. So, by January 31, they were on their way back to Alabama in a chauffeur-driven limousine. Zelda suffered from hallucinations all the way home.

Less than two weeks later Zelda Fitzgerald was admitted to a mental hospital. For the rest of her life, she was in and out of such facilities,

never quite regaining her sanity. It was not the Don CeSar that drove her mad, nor the Florida weather. The seeds of her madness were sown in her family history long before 1932, although perhaps quickened by liquor, fast living and stress. Scott was devastated by his wife's illness. In fact, the story line of *Tender is the Night* is the life of a man married to and desperately in love with a mentally ill woman. In that novel he also refers to a beautiful hotel "in an island wilderness." It is most likely that he was referring to the Don CeSar.

Just how mad was Zelda? At one point in time she believed herself to be in direct communication with God and suffered from other hallucinations as well. At other times, she was quite lucid and even managed to complete her novel while in mental institutions.

In 1948, Zelda's life came to a tragic and untimely end. She was confined in a locked ward of an old hospital, Highland Hospital in Asheville, North Carolina. She was scheduled for an early morning electroshock therapy treatment. A fire broke out in the hospital's kitchen and was soon raging out of control. Zelda and eight other women burned to death, unable to escape the burning building as all the doors and windows were locked shut.

When Zelda passed away, Scott Fitzgerald was already dead. He died of a heart attack in Hollywood on December 21, 1940, at the age of forty-four.

Such a sad end to two lives that showed so much promise in their early days. But perhaps, like Thomas Rowe and Lucinda, they have found each other again. Ironically, Zelda, like Maritana, was named after a fictional gypsy. At the time of Zelda's birth, her mother had been reading a novel that featured a gypsy queen, and she named her daughter Zelda after that character. So, what better place for Scott and Zelda to linger together than the Don CeSar, where they shared their last few happy days in 1932.

There is an inscription above the entrance to the Don CeSar that has been there since the hotel was built. It reads, "Come all ye who seek health and rest for here they are abundant." Thomas Rowe had this message carved in the archway when the Don first opened. Perhaps he knew that spirits would come here someday seeking that rest of which he speaks. Perhaps his own spirit still roams the halls of the grand lady he built in 1928.

SNIPPETS—SHORT STORIES FROM ST. PETE BEACH

HERMAN, THE SCOTCH-DRINKING CAT

One of the best true stories of Pass-A-Grille has nothing to do with ghosts. But it does involve a form of spirits…alcoholic spirits. And a cat.

The Ghosts of St. Pete Beach

In the early 1950s, there was a gray tabby cat that lived with his owner in a small cottage on Fifth Street. The tabby was a large tomcat named Herman. His owner did not have the heart to have Herman neutered, so the tabby often spent his evenings tomcatting around.

Well, one evening, before Herman left on his nightly rounds to visit the local lady cats, his owner accidentally spilled a few drops of Scotch whisky on the kitchen floor. Herman lapped up the beverage enthusiastically, so the owner put a few more drops in the cat's water bowl. This became a nightly ritual. Herman would have his little nip of Scotch before heading out on his evening rounds. But as often happens with tomcats, one morning Herman did not return.

One of the reporters from the *Saint Petersburg Evening Independent* thought that the disappearance of the Scotch-drinking cat of Pass-A-Grille made an interesting story. Now he may have exaggerated a little bit because he made Herman sound like a real feline lush.

The very day that the story ran, a woman wrapped up in mink appeared at the door of Herman's residence. She told the surprised owner not to worry. After all, she pointed out, tomcats usually do come home. "And when he does," she said, "you can give him a real party." She handed Herman's owner a large bottle of Johnny Walker Red Label, a very fine Scotch whisky.

I'm sure Herman's owner had a party, even though poor Herman himself was never heard from again.

Mrs. Outland and Her Cats

The house at 700 Pass-A-Grille Way was built for Mr. and Mrs. V.K. Outland in 1920. Mr. Outland was a poet who wrote a famous poem called "Reveries" while living there. During World War II, the Outlands were kind enough to open up their home for USO dances and parties.

Mrs. Outland was what some would call eccentric and others might call downright weird. She kept cats as pets, and not just a few cats, but many, many cats. She believed that each one of her cats was possessed by the spirit of one of her deceased friends. Therefore, she collected and cared for cats with an enthusiasm bordering on the fanatic. She became known in Pass-A-Grille as the "Cat Lady." No stray animal was ever turned away. All were fed and cared for, but as you can imagine, the number of cats finally reached untenable proportions.

After many complaints from the neighbors, the city of St. Pete Beach stepped in and took the cats away, placing them up for adoption in local animal shelters. Mrs. Outland's heart was broken. She never quite recovered from the loss of her "friends" and died soon after. However, the

house still has an uncanny attraction for cats. The animals are often seen on the steps and along the walls of the second-floor balcony. Are they real or ghostly images? Mrs. Outland herself is never seen, but a high-pitched female voice is sometimes heard calling out, "Here, kitty, kitty!"

THE HUBBARD HOUSE

In 1929, George and Anna Hubbard (parents of Captain Wilson Hubbard, who appears in the John's Pass section of this book) arrived in Pass-A-Grille. As previously mentioned, upon their arrival, they were the owners of a traveling carnival, but they sold that business after the stock market crash of 1929 and settled in Pass-A-Grille.

In 1948, the couple purchased a hotel that stood on property at the corner of Pass-A-Grille Way and Ninth Avenue. They paid only $12,000 for both the lot and the building, and they named the hotel Hubbard House. The place was quite successful, in part because Anna was such a great cook. She was famous for her raccoon stew. The idea of a stew made from raccoons seems to elicit a rather negative reaction today, but in those days it was quite common. The flavor is somewhat like that of squirrel, although not many people today have tasted squirrel either. Anna used to parboil the raccoons with onions and cook them in a big iron pot and serve them with brown gravy and potatoes. On cool winter evenings, those nights when comfort food like a hearty stew would be a popular choice, Anna would make her famous stew. Residents of Pass-A-Grille and tourists alike would flock to the Hubbard House for a hearty meal.

The Hubbard family ran their hotel until the mid-1970s when it fell prey to corrupt city officials who coveted the property. The hotel was condemned and torn down. For whatever purpose the city had acquired the property never came to pass, for the lot sits empty to this day. But the locals say that on chilly evenings in December, January or February, you can still smell the savory aroma of Anna Hubbard's wonderful raccoon stew wafting on the evening breezes of Pass-A-Grille.

KITTRIDGE RESIDENCE

E.G. Kittridge and his wife Laura visited the Tampa Bay area beaches in the early years. They were quite wealthy as Kittridge had made a fortune in Vermont in the quarrying of granite for building supplies, and of course, for tombstones. They were so excited by the wonderful fishing in these parts that they decided to stay and built a home in Pass-A-Grille on Eighth Avenue. In the late '20s or early '30s, a subsequent owner moved

the home to a different location at 103 Tenth Avenue. It remains there to this day. Apparently, the Kittridges moved right along with the house.

The home is currently broken up into smaller apartments, and one of the tenants told us that she frequently experiences the presence of the Kittridges. She has seen both E.G. and Laura Kittridge wafting through the halls of her apartment in the form of misty apparitions. She also tells us that Laura Kittridge is a "neat freak." Apparently, Mrs. Kittridge is never satisfied with the way the current occupant cleans the house, especially the kitchen. Furniture has been known to slide from one location to another, as if Mrs. Kittridge thinks too much dust has accumulated beneath them. Whenever the tenant cleans the kitchen and then leaves the room, all the drawers and cupboard doors are standing open upon her return. She says she finds the spirit's intrusions to be quite annoying. "If she wants it cleaner," says the tenant, "she should clean it herself!"

Eighth Avenue

Eighth Avenue, once simply known as Main Street, is the very heart of Pass-A-Grille. The overhanging second stories on the old storefronts that still line both sides of the street are reminiscent of the French Quarter in New Orleans, although obviously not on as grand a scale. The street was once called "America's most beautiful main street," by no less a personality than Robert Ripley, who became famous for his "Believe It or Not" museums and books. That may have been a slight exaggeration, but it certainly is a lovely street, even today. And it's certainly short, for it is only one block long, from the Intracoastal Waterway to the Gulf of Mexico.

The first hotel in Pass-A-Grille was called the Bonhomie (French for "good fellowship"), opened in 1901. Built by George Henri Lizotte, it was the first hotel along the beaches of the barrier islands near Tampa Bay, according to Frank T. Hurley Jr., a local historian. The Bonhomie was a little on the rustic side. Lizotte used to say that all his guests used the same bathtub—the Gulf of Mexico.

George was quite a character. He used to summon tourists to dinner with a cow horn. The sound of the cow horn would always start Lizotte's old hound dog baying. He always said to the dog, "Shut up, you don't have to eat it!" The tourists loved it! To increase tourism, he would go to other islands and gather shells and plant them along the beach at Pass-A-Grille so the tourists could find them.

He also conducted alligator hunts. He had one alligator that was very old and very tame. Lizotte kept this alligator in a pen behind the hotel. When he wanted to increase business, he would let the alligator loose and put out the word that "a dangerous alligator was running wild" on

Pass-A-Grille. He pulled this stunt so often that the alligator, when found, would roll over on his back and wait to be trussed up and taken back to his pen. Unfortunately, he pulled this trick once too often. Someone shot the poor creature and that was the end of the alligator hunts.

We have not had any reports of an alligator ghost haunting Pass-A-Grille. Nevertheless, Eighth Avenue does have a ghost or two. In 1902 a young widower by the name of Joseph E. Merry moved to Pass-A-Grille with his son, Kenneth, who was four years old at the time. Grieving over the recent death of his wife, he hoped to start a new life on the shores of Pass-A-Grille. He opened a bait shop on the Eighth Avenue dock, along the Intracoastal Waterway, and rented fishing poles to tourists. Later he added groceries, making his shop the very first general store on the barrier islands. In 1912, he moved his store to 107 Eighth Avenue. Joseph Merry lived here in Pass-A-Grille until his death in 1917.

His store is now an art gallery and shop. When the owner was asked if she had ever felt the presence of Joseph, she said she has never seen a ghost nor has she experienced any cold spots or strange fragrances wafting through the air. But every morning, when she arrives at the gallery, all of the pictures that are hung on the walls in the front part of the store are hanging at odd angles and have to be straightened before she can open the door for her customers. Sometimes artwork has actually been removed from the walls and windows and lies face down on the floor. Apparently, Pass-A-Grille's first island retailer doesn't like the art dealer's displays at the front of the store and moves them around to his satisfaction. He doesn't seem to have a problem with the back of the store however. Nothing in the back is every disturbed.

Kenneth Merry, the son of Joseph, also made his home in Pass-A-Grille, building 105 Eighth Avenue twenty-eight years after 107 was built. It was the post office for many years, run by Kenneth's wife Blanche. The original, ornate 1930s post office boxes are still in use. Kenneth lived longer in Pass-A-Grille than anyone else, before or since. He lived there from the time he was four years old to his death at eighty-three years of age on September 30, 1981. Blanche followed him in death just one year later.

But Blanche, it seems, never really retired from the post office. Those who work on Eighth Avenue have said that if they arrive at work early on a foggy morning, they see a light on in the hallway where the old post office boxes still stand. If they look into the window, they see a small, gray-haired woman standing at the boxes sorting mail and putting it into the boxes. But even as they look, the woman disappears. These witnesses have said that they feel no threat from "Blanche," just a concern that the citizens of Pass-A-Grille continue to get their mail on time.

The Ghosts of Gulfport

Nestled between Boca Ciega Bay and St. Petersburg is the little town of Gulfport. In some ways, it seems to be a place that time and tourism have passed by. It retains the character of a small town, even in bustling Pinellas County.

The town has had several names over the years. It began as Barnett's Bluff shortly after the Civil War. For a time it was the home of the largest landowner in the United States, Hamilton Disston, who hoped to make it into a thriving commercial center, and named it Disston City in 1884. In 1905, the town name was changed to Veteran City, a retirement haven for Union army soldiers. It was finally christened as Gulfport in 1910.

It is a fabulous town to visit, especially on the first Friday and third Saturday of the month. On those evenings, an event known as the Art Walk fills the main street with music and craft vendors. But look behind the surface, and you'll find some places where spirits of the departed linger, and often try to make contact with the living.

THE PENINSULA

The Peninsula Inn and Spa stands at 2937 Beach Boulevard in the heart of downtown Gulfport. The beautiful building, with eleven lovely guest rooms, was built in 1914 and originally called the Bay View Hotel.

There were problems with this project right from the beginning. The first developer was a fellow named Ellsworth Chandler, but he suffered a stroke and died before he could begin construction. Then a man named

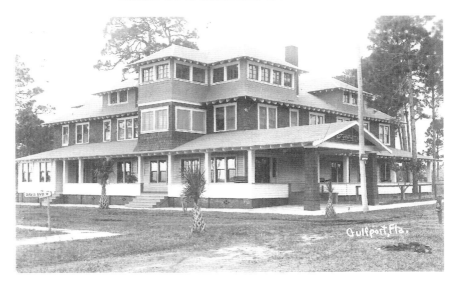

The Bay View Hotel, built in 1914, later the Cedars Restorium. *Courtesy Gulfport Historical Society.*

Frank J. Davenport took over the project. He actually managed to get the hotel built, and the grand opening was held in November of 1914. But within two years he too was gone. He went bankrupt and skipped town, leaving his debts behind him. The hotel changed hands so many times in the next few years that no one is exactly sure just how many owners and/ or managers came and went.

Finally, in 1950 the hotel became a restorium, or what today we would call a nursing home, known as the Cedars. According to Lynne Brown, Gulfport's resident historian, "During those years, nearly everyone who died in Gulfport died in the Cedars."

After the nursing home closed in 1964, the building itself sat vacant for many years. During that time, a local boy by the name of Eric Larson was riding by on his bicycle one afternoon when he looked up at the empty building and saw two people looking back at him from a window on the third floor. As he lived just a few blocks away, he quickly rode home and told his mother about the incident. His mother, although skeptical, agreed to come downtown and have a look at the building. When she arrived there were no longer any apparitions in the third-floor window, but she turned pale when Eric pointed out the window that had formerly contained the figures. Eric's mother told him that his great-grandparents had lived the last

few years of their lives at the Cedars and that they had both passed away in that very room. When mother and son returned home, she got out some old pictures and showed him his great-grandparents. It was the couple he had seen looking out at him from the window in the empty building.

The current owners of the Peninsula Inn and Spa are Robert and Karen Chapman. They too have seen a specter from the past residing in the inn. Although they have no idea as to her actual identity, they call her Isabelle. Robert said he was in the hallway that leads from the lobby to the bar when he saw a woman walking down the hallway with gray hair and dressed in flowing white. He said she appeared so real to him that he was just about to speak to her and ask if he could help her, when she simply vanished.

Guests on the third floor have also reported that someone lifts the coverlet and tickles their toes in the middle of the night. And one of the rooms has a small rolled pillow that Isabelle seems to like to move about. The pillow belongs snuggled up against the two large bed pillows in their matching shams. But our friendly spirit prefers it to be in the middle of the bed. When the room is made up and ready for guests, the pillow is placed where it belongs. But when someone actually checks in, the pillow is smack in the middle of the bed. Guests will sometimes move the pillow back to its proper place, or even put it on a chair or on the dresser, only to find it moved back to the middle of the bed a few minutes later. Whenever they leave the room, the pillow is back in the middle of the bed when they return. Robert reports that he has had two couples check out of that room. One couple left because they believed Robert when he told them the pillow was being moved by the spirit of Isabelle, and they didn't want to share their room with a ghost. The other couple checked out because they *didn't* believe Robert's story about Isabelle. They thought that he was letting himself into their room while they were out.

In February of 2005, a couple came to enjoy a Valentine's Dinner at the Peninsula's fabulous gourmet restaurant, Six Tables. Planning to enjoy the fine wines offered with their meal, they also booked a room. They were given the Serengeti Suite on the second floor of the Peninsula. Nothing unusual happened at first, but the woman woke up exactly at 4:00 a.m. She said she knew it was that exact time because she looked at her watch on the bedside table. She said it was quiet, quiet as only an old hotel can be. She could literally hear the blades of the ceiling fan swooshing through the air.

Just seconds after she awakened, the silence was shattered by a loud banging. This awakened her husband who described the noise as sounding like "someone hitting an old iron radiator with a pipe wrench." The sound continued for a few moments, and then stopped just as suddenly as it had begun. But then the sounds of someone pacing began above their heads, as if someone was walking from one end of the hall to the other and then back again. At exactly 5:00 a.m. the pacing stopped directly above their heads. No further sound was heard.

The next morning they asked Karen about the pacing. "It's Isabelle," Karen replied. "We think she is trying to get out, and that's the banging, and then she paces the floor for that hour in frustration because she cannot escape." Karen confirmed that it only happens between 4:00 and 5:00 in the morning. Interestingly enough, these sounds are never heard by anyone on the third floor. Only people on the second floor ever mention the strange early morning sounds.

Some of the staff is convinced there is also the ghost of a man who prefers to stay in the corridor behind the front desk that leads to the Six Tables restaurant. They have said that his presence is far different from Isabelle's. The feeling they get from his spirit is very nasty. Fortunately, he stays in his corridor and doesn't bother the guests.

One of the waiters described seeing a little girl with blonde hair and wearing a white dress. She was standing in one of the main floor hallways. Then she turned and walked right through a wall. Interestingly enough, the wall had been added during the most recent renovation. That space was formerly a door.

Lately, there have also been sightings of a ghost cat. Sometimes it is curled up on a chair in the third-floor hallway, and sometimes it is seen walking right through that same wall next to the lobby.

The Peninsula is the perfect place to stay in Gulfport. And also a great place for fabulous foods and fine wines. Just be prepared to share your space with the spirits of the past.

Karen Gregory

Gulfport is a quiet, quaint and neighborly town. However, in 1984, there was a horrendous event that shook Gulfport to its very foundation. A gruesome murder took place in the midst of one of the quiet neighborhoods. That murder in turn led to a haunting. The house in

which the murder occurred still stands on the Northwest corner of Upton and Twenty-seventh Avenue.

At the time of the murder, the house in question was the home of a young man named David Mackey. In May of 1984, David had been a happy fellow. He had just met the love of his life, a girl named Karen Gregory, and he had convinced her to share his home on the quiet streets of Gulfport.

Shortly after she moved in, David had to leave for a week to attend a conference in Providence, Rhode Island. So Karen stayed in the small house alone. In the early morning hours of a hot May night, a woman's anguished scream for help pierced the humid air. Eleven different households would later admit that they heard the scream. Yet not one of them picked up the phone and dialed 911.

Two days later the Gulfport Police Department received a frantic long distance call from David Mackey. He had been unable to reach Karen Gregory by telephone. She wasn't answering at home. She had not been in to work for two days, and she had not called her boss with an explanation. She was not staying at any of her friends' homes either. This was not like Karen at all. David begged the police to go to his house and investigate.

Upon entering the home, the police found the brutalized and mutilated body of Karen Gregory. She was lying in a pool of her own dried blood in the middle of the hall. She had been stabbed repeatedly. Because two days had elapsed, much of the evidence was unusable. There were bloody fingerprints on the body itself, but as the blood had two days to spread and coagulate, the prints were totally useless. The only clear print was a bloody bare footprint in the bathroom. But of course, they would need a suspect to match with that footprint. An immediate investigation was launched. But over a year later, there was still no good suspect.

David, understandably, could not bring himself to live in the house. He moved to a home in Tampa and rented out his Gulfport property. Ironically, the police were summoned to the same house again in response to a reported burglary. When they brought their scent dog into the house, the animal immediately indicated there was danger in the home. The dog went into the bedroom, where it was believed the attack began, and gave his indication that there was a perpetrator in the room. The police searched the entire house and yard and found no one. What was the animal sensing?

After over a year, the police began to suspect a very unlikely person. George Lewis, a member of the St. Petersburg Fire Department and Karen's neighbor to the southeast, had been a witness for the police

investigation. He described hearing the scream and going out to investigate. But one of the investigators, Sergeant Larry Tosi, noticed that Lewis's story kept changing, nothing incriminating, just small changes each time he was interviewed, as if he were making up the story and had trouble recalling the details of his previous lies. Police asked him to take a lie detector test. First he tried to avoid the test, but finally he agreed. The test indicated that his whole story was a lie.

The police were then able to get a warrant to obtain George Lewis's footprint. It matched the bloody bathroom print perfectly. Again he changed his story. Now he claimed that when he heard the scream he went into the house to see what the problem was. He saw the bloody body on the floor, but Karen Gregory was already dead. Then, he said, he panicked. And that's why he never dialed 911 or called the police, even though two full days went by before the body was discovered.

It is difficult to believe that Mr. Lewis would be subject to such panic. As a firefighter and paramedic, he had been trained to deal with situations such as this. He was given another lie detector test with this new story. Once again he failed.

Brought to trial in 1987, Lewis was convicted and sentenced to life in prison. However, to this day he claims he is innocent and continues to file appeal after appeal.

The current owner of this house, Stephanie Berlotti, purchased the house in 1994. She was new to the area, but knew the house she was buying was the site of a murder. She didn't think it would be a big deal and proceeded to move in on October 31. When she walked into the kitchen, a black witches hat was sitting on the orange counter. She felt the hairs on the back of her neck stand on end.

After she had settled in and arranged her furniture, her neighbors told her that she had chosen Karen's bedroom as her own bedroom and her bed was set in exactly the same place as Karen's bed had been. Every time she walks between the bathroom and the bedroom she has to step over the spot where Karen's body lay for over forty-eight hours. On that spot there is a dark brown stain. Stephanie has tried several times to remove the stain. It does go away after a thorough scrubbing, but a few days later the stain always reappears. Stephanie has given up. She keeps the spot covered with a Persian rug now.

Whenever she tries to open the bedroom window—the window by which the murderer entered and exited—the glass shatters. Her dog

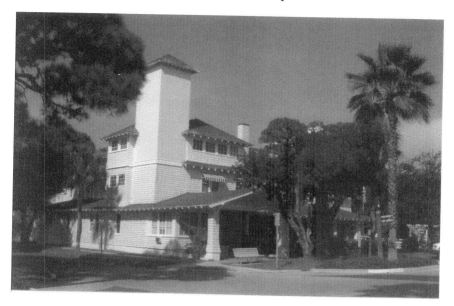

The Peninsula Inn and Spa as it looks today. *Courtesy of St. Petersburg Museum of History.*

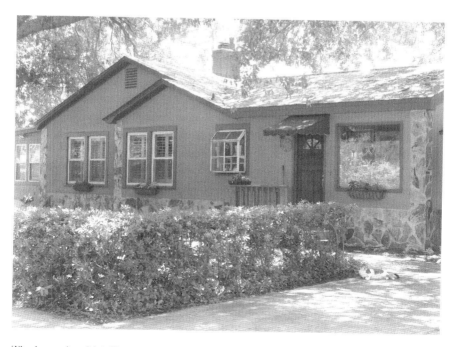

The house in which Karen Gregory was murdered in Gulfport. *Photograph by the author.*

and two cats will spend hours staring at the bedroom wall. Once she saw a misty image of a woman's face behind her in the bathroom mirror. And when her mother came for a visit, she heard footsteps running through the empty house, as if a woman were trying to flee from an attacker.

Stephanie still lives in the Gulfport home. She has made a few additions to the property and repainted the exterior. She has no qualms about sharing her house with Karen. In fact, she believes that Karen saved her life one night by waking her up when a fire had started in the kitchen. She even listens for Karen's advice when decorating their mutual home.

Why does Karen's spirit linger? Perhaps it is because George Lewis continues to protest his innocence and has filed several appeals. Stephanie believes that Karen will not rest in peace until George Lewis admits his guilt, or he himself dies. Karen Gregory's spirit does not want anyone to forget the horror of her death.

THE CAT AND THE CASINO

Today the word "casino" conjures up pictures of smoke-filled rows of slot machines and blackjack tables. However, the earliest meaning of the word in central Florida was simply "community gathering place." St. Petersburg had a casino at the end of its Million Dollar Pier from 1926 to 1967. It was not a gambling establishment, but a dance hall and meeting place.

Gulfport Casino was built in 1906 and still retains its original spot. Built on huge pine pilings, the first casino building was quite an attraction. It was a dance hall, a meeting place and a stop for tourists on their way to the Gulf beaches. The trolley line that ran out to Gulfport from St. Petersburg went right out over the water on a dock next to the casino. Launches took people over the bay to tourist spots in Pass-A-Grille and St. Petersburg Beach. Unfortunately, this first building was destroyed by the great hurricane of 1921.

The current building was built in 1933, which of course was the zenith of the Big Band Era. Very late at night, when the building is closed and locked, locals claim that you can hear the ghostly strains of 1930s music coming from inside the casino. Legend has it that a dancing couple materializes on the dance floor at 3:00 a.m.

The Gulfport Casino. *Courtesy of St. Petersburg Museum of History.*

The grave of Morris, the Casino Cat. *Photograph by the author.*

Right next to the Gulfport Casino, on the shores of Boca Ciega Bay, stands a grave marker. It is not just a memorial, but also an actual gravesite, containing the ashes of the deceased. However, the deceased is not a human being, but a cat.

In 1970, a stray, orange tabby cat became the "cat who came to dinner," when he appeared at the casino and never left. He bore a strong resemblance to "Morris the Cat," made famous in television commercials for being finicky about his cat food. So naturally, the locals named him Morris. Although he was not allowed inside the casino, he soon became the official mascot. The staff made sure that he was well fed, taken to the vet and frequently petted and scratched behind the ears. Everyone loved Morris.

His favorite activities were sleeping in the flowerbeds that surrounded the building and chasing little crabs and other critters down the beach. He lived at Gulfport Casino from his arrival in 1970 until his death in 1985, when he was found permanently asleep in the flowers in front of the casino. His many fans could not bear to part with the memory of Morris, and so his body was cremated and his ashes were placed in a pillar next to his favorite beach. Apparently there are still many of those fans about. The pillar often has fresh flowers or little stones or toys left next to the concrete effigy of Morris sitting on the top. That effigy was originally a lovely little brass kitty cat. However, sometime during spring break of 2005, someone must have thought it would make a good free souvenir, as it was stolen one night from the top of the monument. It was then replaced with the current painted cement figure. One can't help but wonder if any regrets haunt the thief.

People often report seeing small "dust devils" on the beaches. We believe some of these swirls of dust may be Morris out for his daily stroll on the beach, chasing some imaginary prey. He seems happy to remain here near his "Mansion by the Sea."

THE TROLLEY

For many years in the early twentieth century, the best way to get to Gulfport was onboard an electric trolley that ran down Beach Boulevard and out onto a pier right next to the Gulfport Casino. The trolley was the brainchild of one Frank Davis. He was born in Vermont, but moved to Philadelphia, Pennsylvania, when he was thirty years old. Like many

other Northerners, he originally came to Florida for his health, first arriving in Pinellas County in 1890. Mr. Davis's passion became the modernization of the small towns of the Pinellas Peninsula. He built an electric plant in downtown St. Petersburg, making it the first town on the peninsula to have electric lights. The plant operated from sunset until midnight each day. After all, who needs electricity during the daylight hours or the middle of the night? Then he set his sights on starting a trolley company for St. Petersburg.

But about that same time another fellow had made big plans for the little town, which was then known as Disston City. His name was Colonel John Chase, and as a member of the Union army during the Civil War, he hoped to establish a retirement community for his fellow veterans. He was able to convince the citizens to change the official name of the town to Veteran City.

April 5, 1905, was a big day for the Pinnellas Peninsula. Frank Davis's trolley made its first run, and Veteran City held a grand opening. The town partied for the entire day, and some people well into the night.

The trolley was very expensive for that time. The charge for the trolley was fifteen cents to go from St. Petersburg to Veteran City, but only ten cents to get back. Perhaps they were afraid that if they didn't charge less to return to St. Petersburg, nobody would leave. But most of the folks riding the trolley were not actually planning on staying in Veteran City. They were more interested in taking the launches and steamships that waited at the end of the line out to the Gulf beaches. But the casino did begin to attract many patrons.

Veteran City was never a success. After all, by 1905 the veterans of the Civil War were getting up in years. Few of them wanted to uproot themselves for an unknown destination in Florida, particularly in the days before air conditioning.

The trolley, while not a complete failure, always had its ups and downs, but it continued to run for many years. Finally, it gave way to buses in the late forties. The tracks themselves are still there. They are resting underneath the pavement of Beach Boulevard.

However, at midnight, the sounds of the last trolley run, from Gulfport back to St. Petersburg, echo along Beach Boulevard. Nothing is seen. No shade or shadow passes by. Just the distinctive rattle of the old trolley car forever tracing its run along that final route.

THE ROLYAT

In the mid-1920s, Gulfport became quite a boomtown. A gentleman by the name of I.M. Taylor (better known as Handsome Jack) built a grand hotel in 1926. It was known as the Rolyat Hotel (Rolyat is just Taylor spelled backward). Handsome Jack was married to one of the daughters of the du Pont family of DuPont chemicals. Whenever he wanted to make an investment in Gulfport, he would just turn to his wife, and she would lift the skirt of her flapper dress and take a wad of $100 bills from her garter and start peeling them off.

This infamous Jazz Age couple later divorced. In fact, Evelyn remarried a man by the name of Aden Pierce. She visited Gulfport at least twice more. What eventually happened to her is not known.

The Rolyat is an excellent example of the Mediterranean Revival style of architecture, and many fine homes were built in the same style in the surrounding area. The fabulous hotel became Stetson College of Law in 1954. But law students at the facility still claim they see a woman in a flapper outfit roaming the halls of the college. Could it be Mrs. Evelyn du Pont Taylor checking up on her old investment?

LA COTE DE BASQUE WINEHOUSE

Along the east side of Beach Boulevard in Gulfport sits a warm, friendly restaurant with a European flair. La Cote de Basque Winehouse restaurant is definitely a family business. Currently, two sisters, Carmen and Simone, run the establishment. It was their father, Ernest, who started the business many years ago. He was a veteran of World War II, but not on the side of the Allies. He actually fought in North Africa under General Rommel in the German army. After the war, he and his Swiss wife, Theresa, moved to Gulfport and opened the restaurant, serving fine French and German cuisine.

Ernest passed away just a few years ago, but his spirit seems to want to keep tabs on the operation of the restaurant. Simone and Carmen both say they can sense their father's presence throughout the restaurant. Along one of the walls near the front window there is a light fixture in the form of a double sconce with fabric shades. The two sisters claim that whenever their papa is displeased with anything

they are doing in the restaurant, the light will flicker. They have come to view it as a message from their father that they need to watch what they are doing!

In the rear of the restaurant, there is a large room for private parties. One of the waiters had a fascinating experience in that room. One night, he had the many tables all set for a large group, with wine and water glasses in place, as well as napkins and forks, knives and spoons. He left the room for only a couple of minutes. When he returned all the glasses on the tables had been turned upside down. Furthermore, the positioning of the silverware had been reversed. All the knives and spoons were where the forks and napkins should have been, and vice versa. The waiter said it was impossible for any human being to have entered the room and made those changes in the time he was gone.

One of the hostesses also had a strange tale to tell. She said that one evening she saw a misty vapor appear right in front of her in the back hallway near the bathroom. She said the vapor was quite large, and there was no natural explanation for its presence in the hallway. As she watched, the vapor traveled past her and continued down the hallway until it reached the corner of the restaurant by the private dining room. As the vapor passed her, she felt an eerie chill, which seemed to go right through her. This particular hostess was so shaken by the experience that she now refuses to go into that particular hallway if she is alone in the restaurant.

Who is the mischievous spirit in La Cote de Basque? If it is Ernest, he certainly does not want to frighten anyone. And although encounters with him can be a bit unnerving, Simone and Carmen think their father makes his presence felt as a reminder to them. A reminder that they should take good care of the legacy he left behind, La Cote de Basque Winehouse.

Sunshine Skyway

There are four bridges across Tampa Bay. The first three connect Hillsboro and Pinellas Counties. The fourth and southernmost of those bridges provides a connection between Pinellas and Manatee Counties. This bridge is known as the Sunshine Skyway, and although it is not actually in Gulfport, its lofty outline can be seen from the Gulfport

Municipal Pier. Originally built in 1954, it was given its name by a local resident named Virginia Seymour. She entered a contest to name the bridge and beat out twenty thousand other entries with the name that came to her "right out of the blue."

In the early morning hours of May 9, 1980, disaster struck the bridge. Or more accurately, a large ocean-going freighter, the *Summit Venture* struck the bridge. A section of the bridge completely collapsed and fell into the dark waters of the bay below. Several cars and a Greyhound bus simply drove off the broken edge of the bridge into nothingness, falling for 150 feet to certain death. Thirty-five people lost their lives that morning.

The original span has now been replaced by a gleaming, golden new bridge, worthy of its name. The remnants of the first bridge extend from both sides of the bay and have been converted into two fishing piers.

Ironically, the most often reported ghost story of the Sunshine Skyway has nothing to do with the tragedy of 1980. In fact, the sightings of this particular ghost began soon after the first bridge was completed. As the structure was very high, in fact high enough for huge freighters to pass underneath, it immediately became a popular place for suicides. There have been many reports of a blonde hitchhiker who may very well be the ghost of one of the despondent souls who leapt from the bridge.

Several people have claimed that they picked up a hitchhiker near the tollbooth on the northbound span. Some describe her as dripping wet. Others say she appears completely normal as she climbs into the back seat of the car. As the car approaches the bridge, the young, blonde stranger is very talkative. But the closer they get to the summit, the quieter she becomes. Once they pass the top of the bridge, there is total silence from the back seat. When the owners of the vehicles turn to look in the back seat, the hitchhiker has completely disappeared.

Another ghostly presence has been reported from one of the fishing piers made from the old bridge. Early on a foggy morning, two men were getting in some snook fishing before work. It was deathly quiet on the pier when they arrived, but soon the silence was broken by what they described as a high-pitched whining sound. As they looked up, they saw a Greyhound bus approaching along the closed span. The bus was a ghostly shadow in the morning mist, and it seemed to pass right through them like a cold wind. As the bus went by, the two men

saw the people on board. The driver was staring straight ahead. His grip on the steering wheel was so tight that his knuckles were white and strained. All the passengers were also staring straight forward. Except for one woman at the very back of the bus. According to these witnesses, she looked at them out of the back window, and smiled and waved as the bus plunged on into the mist.

The Ghosts of Downtown St. Petersburg

St. Petersburg, Florida, was a byproduct of the railroad. The first train rumbled into town, which was then called Wardsville, on June 8, 1888, due to a deal struck between the founders of the town, John and Sarah Williams, and the Orange Belt Railroad Line. The line was owned by a Russian-born gentlemen by the name of Pytor Alexandrovich Dementyev. Difficulty of pronunciation caused him to shorten his name for the locals. He simply called himself Peter Demens.

There are several different stories regarding how the name change to St. Petersburg was actually decided upon. But all the stories agree that it was to honor Peter Demens who grew up near St. Petersburg, Russia. The new town was officially incorporated on February 29, 1892, making St. Petersburg a relatively young town. But there are still plenty of spirits walking its streets.

THE BATHROOM AND THE MUSEUM

As you head out onto the pier in downtown St. Petersburg, if you look to your left you will see Comfort Station Number One, and right next to it, the St. Petersburg Museum of History. Both buildings are local landmarks, and both are haunted.

There is an old urban myth in St. Petersburg about the small, octagonal brick building known as Comfort Station Number One. At the

The Ghosts of Downtown St. Petersburg

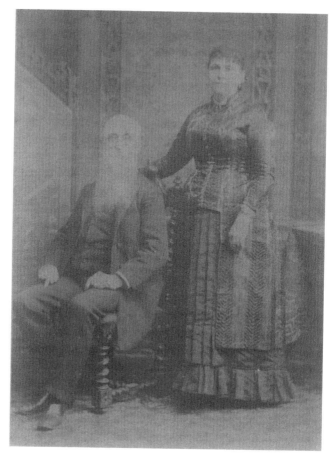

Above: Central Avenue in early St. Petersburg circa 1897. The large building was built by John and Sarah Williams as the first hotel in St. Petersburg. *Courtesy of St. Petersburg Museum of History.*

Right: John and Sarah Williams, founders of St. Petersburg. *Courtesy of St. Petersburg Museum of History.*

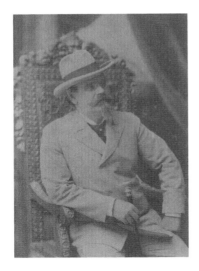

Left: Peter Demens, owner of the Orange Belt Railroad Line. *Courtesy of St. Petersburg Museum of History.*

Below: Comfort Station Number One in downtown St. Petersburg. *Photograph by the author.*

time it was built, it was the city's first public bathroom, hence the name. It was designed by the same architect who built St. Mary's Catholic Church just a few blocks to the south. There is a remarkable similarity between the two buildings. Both are octagonal in shape and built of brick in the Romanesque Revival style. The legend is that Henry S. Taylor, who designed these two structures, was angry at the church for "stiffing" him out of some of the money he was owed, and therefore he deliberately designed this public bathroom to resemble the church building.

Nice story. And you'll hear it from tour guides and trolley drivers over and over again. Unfortunately, it's not true. The Comfort Station was built in 1927 for a cost of $16,000. The church was not built until 1929, so the public bathroom was completed long before any payment was even due for the church.

But the building does have a ghost. We are not sure who it is, but we know it is a female, for the odd presence has only been encountered on the ladies side of the bathroom. Cold drafts have been reported even on very hot days, as well as misty images in the mirrors. The most vivid ghost sighting here occurred in 1999 when a couple of tourists from Wisconsin were visiting the city. They were sisters who were enjoying their last day in the sunshine before heading back to the "frozen tundra." One of the girls went inside while her sister decided to wait outside. The young lady said that as she entered, all the doors to the stalls were ajar and she was clearly alone in the bathroom. But shortly after she entered one of the stalls and shut the door behind her, she heard a noise in the stall next to her. Thinking her sister had decided to come in after all, she said, "Heather, is that you?"

An elderly woman's voice came from the other side. "No, it's Agnes."

Feeling a little foolish, the girl wanted to be friendly, so she said, "Nice to meet you Agnes. How long have you been in St. Petersburg?"

Agnes answered, "A long, long time".

The girl looked down and saw an old-fashioned, 1930s-style shoe on the foot of the woman in the next stall. Feeling nervous now, she quickly finished what she had come to do, and then left the booth. The stall next to her was completely empty. She ran outside and asked her sister if she had seen anyone come out? Heather had seen no one.

Who was the woman? No one knows. A long ago tourist who needed a rest stop? A member of St. Mary's Church who got confused?

Many of the locals refer to the comfort station as the "St. Mary's Comfort Station," or "Little St. Mary's." Perhaps it should be referred to as "St. John's."

Right next to the Comfort Station is the more modern building that houses the St. Petersburg Museum of History. This local museum really started out as a sort of "collector's club," according to one of the archivists. It was begun in the early days of St. Petersburg in order to preserve the history of the city as its artifacts accumulated. But not all of the artifacts inside are from St. Petersburg. In fact, one corpse and one decapitated head reside inside these walls. Their original home was ancient Egypt.

In 1922 the yacht *Tamiami* put into nearby Bayboro harbor for repairs. The ship arrived carrying the contents of a traveling carnival. When the owner of the yacht was unable to pay for his bill at the harbor, he gave Bayboro Marine Ways a small black coffin that contained a partially unwrapped female mummy. The marine company in turn donated the mummy to the museum in 1925.

For years there was controversy about whether the mummy was a hoax. After all, it had been the property of a carnival. In 1988, an attempt was made to run the body through a CAT (Computerized Axial Tomography) scan, but the coffin wouldn't fit inside, and it was feared she would disintegrate if the coffin were removed. Enter a company called Southern Medical Scanning Inc. They had a special CAT scanner for use on marine mammals. And, eureka! The coffin fit inside, the scan was completed and the mummy was authenticated.

She is a small woman, only four feet, nine inches tall, from about 1,200 BC. Most likely she was a member of the Egyptian middle class, wealthy enough to afford the all-important embalming, but not loaded with gold and jewels like King Tut. Also, her teeth indicated a middle-class diet of mainly bread and little protein.

There was one moment of good comedy during the test. One of the local TV news guys was standing with his hand on the coffin as he waited for a live shot, when suddenly one of the medical technicians pushed a button that caused the coffin to shift slightly. The newsman jumped a foot and turned deathly pale, only managing to compose himself just in time for the shot.

One of the night watchmen at the museum, Bill Watts, claims that our Egyptian lady haunts these hallowed halls. Bill claims to have heard unexplained footsteps and seen a slight black shadow moving about the displays long after all the visitors have gone home.

There was another unusual find in 1993. A volunteer at the museum was going through some old boxes when she chanced across a brown box labeled "Egyptian Woman's Head 19th Dynasty." She opened the box

(brave girl!) and indeed found a woman's head, carefully wrapped in a silk scarf. No one has any idea where it came from. Even the president of the museum at the time described it as a bit of surprise.

The head has also been authenticated by CAT scan. One of the doctors commented, "She has remarkable teeth." The head is not on display at this time. One of the archivists believes that the remains of both women should be returned to Egypt and properly buried. Or perhaps she just doesn't like sharing her workspace with two women who've been dead for over three thousand years!

THE VINOY

Every evening the sumptuous Renaissance Vinoy Resort turns on a red light in its tall tower. That light was originally put in the tower to announce that it was tourist season. Back in 1925, when the hotel was built, it was only open to guests from January through March. Whenever the hotel was receiving guests, the staff would set the red light in the tower to let the locals know there was company in town.

The resort was originally called the Vinoy Park Hotel. And the story of its origin is fascinating. It involves a 1920s Florida land developer by the name of Aymer Vinoy Laughner. This gentleman got this rather odd name because his father was reading a novel at the time he was born in which the main character was an Arabian Sheik named Aymer Vinoy. His father was so taken with the name that he insisted his son be named after the character in the book.

Mr. Laughner's St. Petersburg home was a large, white stucco house that literally stands in the shadow of the Vinoy hotel. Currently known as the Beach Drive Inn, it was often the site of grand entertainments and parties for Mr. Laughner's many friends. On one such evening, the guests included another land developer named Eugene Elliot and a famous golfer of the time named Walter Hagen. They had all enjoyed a few glasses of champagne when they decided to go out on the front lawn and hit a few golf balls. Aymer had been talking all evening about how he should build a new hotel in St. Petersburg, so Walter Hagen, who was a bit of a betting man, decided Laughner should put his money where his mouth was. Hagen placed Laughner's pocket watch on the ground and bet him that he could hit three successive golf balls off of the watch without even cracking the crystal. And, according to the conditions of the

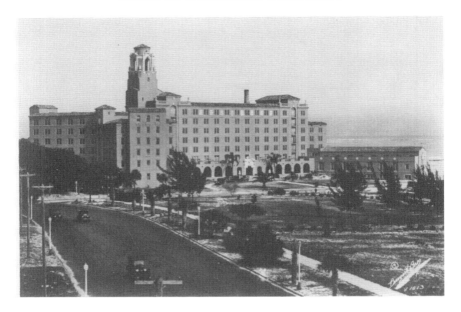

Long view of the Vinoy Park in 1928. *Courtesy of St. Petersburg Museum of History.*

bet, if Hagen could accomplish this feat, Laughner would have to build a fabulous hotel wherever the balls landed.

According to legend, Hagen won his bet. The next morning the three gentlemen purchased the property where the huge hotel now stands from a Mr. Williamson. Supposedly, they wrote up the contract on a brown paper bag.

Laughner's building permit with the city of St. Petersburg required him to complete the hotel before the end of 1925. The Vinoy Park Hotel opened on December 31, 1925, just before his time expired. The carpets were still being installed on the rooms on the upper floors as the first guests were arriving at the front door.

Yet, less than a year later, there were already reports of a ghost within its walls by late 1926. A woman in white drifts along the fifth floor hallway, her diaphanous dress flowing around her. Staff and guests alike have reported this apparition. And she is still seen to this day. Even when she is not actually seen, she likes to make her presence known.

The Vinoy gives historic tours of the hotel. One day, one of the guides was entering the elevator with a family and intending to take them to the mezzanine level, she pressed the "M" button on the elevator controls. The young boy in the group asked if the hotel had any ghosts.

The Ghosts of Downtown St. Petersburg

The guide briefly told him the story about the woman on the fifth floor. Strangely, the elevator did not stop at the mezzanine level, but continued on up to the fifth floor even though that button had definitely not been pushed. The elevator doors opened to an empty hallway. No living thing had summoned the elevator. The doors then closed and the elevator proceeded back down to the mezzanine level. Perhaps it was our lady in white offering confirmation of the guide's story.

Who could this woman be? Do you remember that one of Laughner's companions on that fateful night of the bet was Eugene Elliott? Elliot was a fast-talking, unprincipled promoter who could sell just about anything to just about anybody. When he first arrived in Florida his job was to sell shares in the proposed first bridge across Tampa Bay to link Tampa and St. Petersburg. Reportedly, he was totally surprised when his employer, George Gandy, actually built the bridge. Eugene thought he had been selling a hoax the entire time.

He also tried to increase the value of his landholdings by planting Native American artifacts to generate more interest in the land. This scheme backfired rather badly, for when archaeologists came in to investigate Mr. Elliot's planted artifacts they also found so many of the real thing that sales of Mr. Elliot's lots were halted so an archaeological dig could be done.

In 1926, Elliot's land dealings fell on some very hard times. Saturday, June 26 was a particularly bad day for Eugene Elliott. On that day, he found out that he owed $500,000 in back taxes. This would be the equivalent of over $5 million in terms of today's money. On that same day, his wife, Elsie, like a rat deserting a sinking ship, filed for divorce. There was a nasty confrontation between Eugene and his wife on the back steps of their family home, which ended with Elsie falling backward down the small flight of three steps and hitting her head. Eugene did not seek medical attention for Elsie, but simply carried her up to their room. She died at 7:00 that evening. Elliot never reported the matter to the police and just went about making funeral arrangements. However, the Elliot family maid, Annie Gadsden, brought the matter to the attention of the authorities, and Mr. Elliot was arrested for murder.

At the first hearing Annie was the star witness. She claimed to have witnessed the entire altercation and stated that Eugene had pushed Elsie down the steps in a deliberate intent to cause her bodily harm. Although he continued to protest his innocence, it was determined there was enough evidence to bring Eugene to trial for murder.

Before the trial could begin, however, Annie Gadsden mysteriously disappeared. With no witness, the charge of murder was dropped.

Could the mysterious woman in white be Elsie Elliot haunting the halls of the hotel her husband helped to get started? Or perhaps Annie Gadsden trying to tell us that her disappearance was not a coincidence?

This apparition is not the only ghost at the Vinoy. The professional baseball teams stay here when they come to town to play the Tampa Bay Rays, and several players have reported the appearance of a strange figure in their rooms or waking up and feeling themselves held down tight to the bed by an unseen hand. Some claim that it's the spirit of one of the players who stayed here in bygone days. Some have even gone so far as to claim it is the spirit of the great Babe Ruth himself. Perhaps these ghostly visitors are just trying to give the Rays a hand by unnerving the competition. And suddenly it seems to be working, as the Rays, who used to have one of the most dismal records in baseball, have recently had excellent seasons.

Figures have also been sighted in the tower, even though it is always kept locked. One couple recounted an interesting story of a night they spent at the Vinoy. They were sitting on the bed watching television, when they heard the water in the bathtub turn on all by itself. Perplexed, the woman went into the bathroom and turned off the water. About ten minutes later the water once again began to flow at full force and once more they shut it off. The third time this happened was the last straw, and they called down to the desk to have someone come up and look at the faucet. The woman at the front desk told them not to worry about it. "We always have problems with the water pressure. I'm sure it will stop." Sure enough, the water did not trouble them anymore that night.

The next morning when they went to check out, the front desk clerk leaned over and whispered in a conspiratorial tone. "I heard you met our resident ghost last night!" The couple had been staying on the fifth floor.

A local resident also reported a ghostly encounter at the Vinoy. She had made arrangements to take the historic tour and was sitting outside on the veranda waiting for it to begin, just savoring for a few moments the lifestyle of the rich and famous. She was sitting in one of the veranda's many rocking chairs. There was no wind at the time, and all of the unoccupied rocking chairs were completely still. After a few moments of relaxation, she looked over at the chair next to her. It was rocking gently back and forth as if someone were sitting there. She reached over and stilled the chair. After a brief pause, it began rocking again. She stood

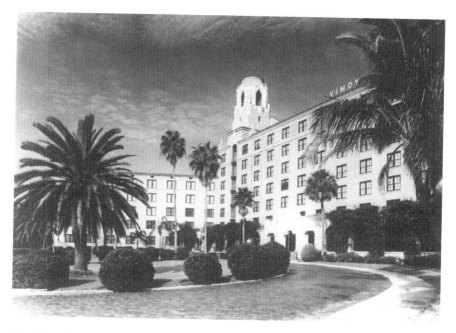

The Vinoy Park Hotel in 1930. *Courtesy of St. Petersburg Museum of History.*

up and felt the cushion of the eerie chair. It felt warm to the touch, as if someone had just been sitting there. She was quite glad that it was time for the tour to start.

Whoever the ghosts of the Vinoy may be, no one has ever come to any harm at their hands. Like the great hotel itself, they seem to be in the business of welcoming people to St. Petersburg.

The Home of Ott and Julia Whitted

In 1884, fate brought two young people together. One was a handsome young man by the name of Thomas Austin Whitted. His friends called him Ott. He came to the little village of Barnett's Bluff, now known as Gulfport, to work in the new sawmill run by another pioneer named Zephaniah Phillips. It was here that he met Julia, the thirteen-year-old daughter of Zephaniah Phillips. The two met and fell in love.

Falling in love with the boss's daughter is not always the smartest thing to do, but Ott was not to be deterred. To make matters worse, the two young people were soon to be separated by a great distance. Julia's father

The family of Ott and Julia Whitted celebrate Christmas in their home in Old Northeast St. Petersburg. *Courtesy of St. Petersburg Museum of History.*

had decided to move his family across the bay to the barrier island of Long Key, near the area known as Pass-A-Grille. Ott had found a new job running a sawmill down on the Manatee River, near what is now the town of Bradenton. But once again, he proved his determination. Once a week for the next three years, in all kinds of weather, he sailed up to Long Key to visit his beloved Julia. He became known as "the suitor in the sailboat."

When Julia reached the "marriageable" age of sixteen, the two were married in her parents' little clapboard cabin. This was the first wedding among the pioneers of the Gulf beaches. The newlyweds returned to Barnett's Bluff for two years, and then moved to St. Petersburg. Ott became very important in the city. He served on the city council and was one of St. Petersburg's leading citizens throughout his life. In 1911, they built a house at 656 First Street North in the Old Northeast Neighborhood and raised eight children within its walls.

One of those children was their son James Albert Whitted. He grew up to become an aviation hero in World War I, one of the first men ever to fly airplanes for the U.S. Navy. After the war he was testing a navy surplus aircraft for a friend who had an interest in buying it. One of the propellers came off and pierced the canvas wing of the plane, sending it and Albert Whitted into Pensacola Bay. Albert did not survive.

The municipal airport in St. Petersburg is named after Albert. But his ghost apparently has a fondness for the home where he grew up rather than the airfield that bears his name. Neighbors have reported the sound of a young child playing along the porch, but there is no child to be seen, although photographs have revealed white orbs of light or an unexplained mist surrounding the porch. Sometimes the unseen child makes the sound of a revving engine. Perhaps it is the ghost of the boy Albert, imagining himself in flight in an early flying machine.

THE SUTPHIN HOUSE

One of the most desirable neighborhoods in St. Petersburg is the Old Northeast. As the first truly upscale area, its streets are lined with an eclectic mix of homes from the early twentieth century. One of those beautiful homes stands at 756 Bay Street. The home was built sometime in the 1920s. However, the ghost is from much more recent times.

In the 1960s, this house was filled with the large family of Van and Judy Sutphin. There were five children in the house, including Tink, Judy's sixteen-year-old son from a previous marriage. In early June of 1968 Judy had a horrible dream. She dreamed that Tink would die just before Christmas. Exactly six months later to the day, in early December, Tink was struck and killed by a pickup truck while visiting a friend in Lakeland, Florida.

From the day of Tink's death to New Year's Eve of that year, the front door of the house would open all by itself, stand open for a few seconds and then close. Judy was sure it was Tink trying to let them know he was still with them in his own way.

Nothing unusual occurred for most of 1969. But in December, near the anniversary of Tink's death, the family was in the dining room putting up a Christmas tree in the corner, so it could be seen from both the front and side of the house. They were untangling lights and sorting decorations when one of the children asked Judy, "Mom, do you really think that was Tink visiting us last year?"

Judy replied that she thought it was. But Van, much more skeptical, dismissed the notion as nonsense. Judy then said, "What would it take for you to believe that it was Tink? Would the clock have to stop and the chandelier have to fall?"

Van thought that might convince him.

The next morning when the family awoke and came down to the main floor of the house, they thought it seemed awfully quiet. They soon discovered the grandfather clock in the hallway had stopped. It had not run down. It was one of those eight-day clocks that only require winding once a week, and it was only midway through its cycle. Van had no trouble starting it again, and it resumed ticking and keeping perfect time.

That night, when the family sat down to dinner the chandelier fell onto the dining room table, right in front of the astonished eyes of the family. Van was still skeptical. It could have been a piece of dust in the clock mechanism he said. Or perhaps he had installed the chandelier incorrectly. But in 1971 there was another strange incident. When Judy

went out to get the morning paper, there were two child-sized footprints in soft, white beach sand on the front porch. There was no such sand anywhere in the yard, and there were no footprints either leading up to or away from the footprints on the porch.

The Sutphins continued to live at this home without further happenings for many years. In 1998 they sold the property to an elderly gentleman named Bernard Ferry. Mr. Ferry was eccentric to say the least. According to his neighbors he actually buried the cremains of his wife and mother-in-law somewhere in the front yard. He died in the home in October of 2000. For several years thereafter the house sat empty.

The house, which is currently being renovated by new owners, is a regular stop on the Tampa Bay Ghost Tours Downtown St. Petersburg Tour. In fact, it has become the most popular stop because of the many strange things that have occurred during the tours. In May of 2005, a small group stopped in front of this house with their tour guide. One of the ladies on that tour was from Ireland and was very sensitive to the spirit world. As the group looked into the windows of the dining room, the Irish woman exclaimed, "I can see a ghost!"

She pointed at a set of windows and everyone looked. Every woman in the party saw what she was talking about, but the men couldn't see it. Perhaps the ghost was only interested in the women. All the ladies described the same apparition, a tall, young man, well built and well muscled. He was wearing a white or perhaps light-colored, short-sleeved shirt with an open collar. He was staring straight back at the watching women. Despite the detail, he was clearly not of this world. He was not a solid figure but seemed to be made out of a heavy mist. Everyone in the party, including the men, felt their hair stand on end and their skin crawl. They were both fascinated and frightened. Even by the end of the tour, everyone was still talking about the ghost on Bay Street.

Since that time, there have been other strange occurrences. On one evening, a group experienced a sudden wind just as they walked up to the house. The wind was strong enough to toss the arms of the trees around, and every member of the party had sand blown into their faces. As soon as the group walked away from the house, the wind stopped as suddenly as it had started.

On another night, no one saw anything with the naked eye. However, when one of the young men in the group looked at a picture he had taken with his digital camera, there was clearly a figure staring back at him from an empty window.

The current owner does not believe in ghosts. "Those are just stories," she said. Perhaps the restless spirits will move on now and be at peace.

THE COLISEUM BALLROOM

The beautiful Mediterranean Revival–style Coliseum Ballroom stands majestically on Fourth Avenue North, just outside of the thriving downtown area of St. Petersburg. It was built in 1924 as part of St. Petersburg's effort to enter the big time as a tourist destination. The $250,000 spent to build the Coliseum Ballroom was huge for that day and guaranteed that the ballroom would be a place of luxury and grandeur. Over the 1920s and 1930s it played host to some of the finest big bands of the era. Jimmy Dorsey, Benny Goodman, Guy Lombardo and even Glen Miller were all featured at the Coliseum Ballroom. Some sources say that Louis Armstrong also played there. However, other accounts state that he refused to play there, because blacks were only welcome on the stage, not in the audience, nor in any of the local hotels.

From the very earliest days of operation, a man by the name of Rex McDonald often played at the ballroom. When he was only in his teens he became a member of the Coliseum's house band. Then, in 1926 he organized a band of his own. Known as the Silver Kings, Rex's band soon became a favorite at the Coliseum. Rex then became the general manager, and finally the owner of the place. He and his wife Thelma, whose nickname was Boo, owned and operated the Coliseum Ballroom until Rex's death in 1984. Thelma tried to keep it going after Rex died, but she finally sold it to the city in 1989. Thelma passed away on Christmas Day 1999.

After spending over sixty years of his life in the establishment, it's probably not surprising that Rex wanted to continue to hang around. The night watchmen have reported that when they are alone at night and going on their rounds, they often hear a second set of footsteps walking alongside of them. They believe that it is Rex McDonald still keeping an eye on things. Sometimes they hear more than one set of footsteps. Perhaps Thelma joins Rex on those occasions.

The watchmen have also reported the distinctive smell of Rex's famous pipe smoke. And they have seen the curtains that separate the private lounges from the main ballroom lift slightly and then drop back into place, as if an unseen hand brushed them in passing.

The Coliseum Ballroom in St. Petersburg. *Photograph by the author.*

The Coliseum Ballroom remains one of the largest operating ballrooms in the south. Events, shows and dances are frequently held on its 15,500-square-foot, wooden dance floor. And as long as it stands, it seems Rex and Thelma will be a part of its future, as well as its past.

TWO FLAMBOYANT MAYORS

Although some of the founders would like to deny it, St. Petersburg has always had a more scandalous side. Noel Mitchell for example. He got his start in life at age eighteen when he invented a little confection known as saltwater taffy, which became a nationwide hit. He did a little bit of everything after that. He was a carnival barker, an actor and a hotel manager.

Mitchell moved to St. Petersburg in the early 1900s. He became a land developer and ardent supporter of the city. He used to put picture postcards of St. Petersburg in taffy boxes that were going all over the country and the world. He was elected mayor in 1920. There was speculation at the time that he would probably not have won if women had not just been given the right to vote, as he was a handsome fellow.

The Ghosts of Downtown St. Petersburg

One of his great contributions to the city was the famous green benches. Mitchell reasoned that if the tourists had a place to sit down and rest they would spend more time, and hence more money, in St. Petersburg. Originally they were all painted orange, but they were soon changed to the more peaceful green. The benches were a great success and were soon seen all over the city.

But Mitchell only held office for a little more than a year. He was caught having a drunken party in the mayor's office in November 1921. And this was more than poor judgment; this was actually breaking the law. After all, alcohol was illegal in 1921 due to Prohibition. A recall election was held (long before California!), and he was replaced by his political rival Frank Fortune Pulver.

Ironically, Pulver also made his fortune selling something that would rot your teeth. In 1897 he bought the patent on something completely new. He spent $200 for the right to produce a spearmint-flavored gum in small, flat sticks. Sales were dreadful, so ever the showman, he began giving away the sticks of gum for free. Then he staged a fake arrest of himself, on the charge of "giving gum to children." His flamboyant style brought the new confection to the attention of William Wrigley Jr. of Chicago, who bought out Pulver's spearmint gum business in 1913 for the princely sum of $1 million. And the rest, as they say, is history.

Unbelievably, after being elected mayor, Pulver fell into the same routine as Mitchell. He kept having drunken parties in the mayor's office. Some of his enemies even accused him of being a bootlegger. Nevertheless, Pulver actually survived two different recall elections before finally being defeated in a third. He was removed from office in January of 1924. By the age of eighty, he was reduced to running a laundry to pay his bills and keep food on the table, but he never lost his sense of style, for he always wore his trademark white suit and straw boater hat. He died in 1955 at the age of eighty-four.

Noel Mitchell fell on hard times much earlier than did Frank Fortune Pulver. In fact, he was once found dead drunk on one of his famous green benches. He died in 1936. He was penniless and had been living on the streets before he was brought to Mound Park Hospital where he succumbed to pneumonia.

Despite the difference between the years of their deaths, their similarity of lifestyle gave these men a sort of special bond. They have been seen together walking the streets of St. Petersburg, especially around election time, Noel Mitchell in a dark suit and Frank Fortune Pulver in a white

suit. They appear to be deep in conversation as they walk along the streets. Are they cooking up schemes to get themselves reelected? Or are they making plans for a late night party in the mayor's office?

The face of Frank Fortune Pulver has also been seen peering out of the window on the second floor of St. Petersburg City Hall, although that building was not built until 1939, several years after Pulver left office. Maybe he's just looking for someone to join the party.

THE MARTHA WASHINGTON HOTEL

In the early days of St. Petersburg there were no grand hotels like the Vinoy. Most of the accommodations were boardinghouses that catered to both the locals and the tourists. One such place was part of the pink building at 234 Third Avenue North, which is now the Heritage Hotel. This establishment was once known as Mrs. Davis's boardinghouse, although it should more properly have been known as Dr. Davis's boardinghouse.

St. Petersburg actually had several female physicians in the early days, which was rather odd, as lady doctors were very rare at that time. Dr. Marry Davis came to Florida from Pennsylvania. In addition to her medical practice, she ran the boardinghouse, which she had built in the early 1920s. Like many other establishments, it was open only for "the season" of January, February and March.

When the boom times hit in 1926, the property was purchased by a gentleman named Charles Helt who turned it into a fine hotel, which he christened the Martha Washington. He added on several rooms to the original boardinghouse, but like many fine hotels, it fell on hard times in the 1970s and sat empty for quite some time. In 1986, a group of investors purchased the property from Charles Helt's grandson, Ogden Helt. The building was completely renovated in 1986 and reopened as the Heritage Hotel in 1987.

During the renovation period a night watchman was hired to look after the property. He was a practicing Wiccan and always felt there was something strange about the old property. He contacted his high priestess and they went through the hotel with "bell, book and candle" to try to identify the source of the unhealthy feelings.

One area of concern was the cellar storage area. The high priestess said she had experienced a feeling of pain and terror in that area.

The Ghosts of Downtown St. Petersburg

During the years the building was empty, many homeless people took temporary shelter in that area. Perhaps one of their spirits was still trapped there.

Another area of concern was the hallway on the third floor in the oldest part of the building. She said she felt two forces in that hallway. One was good, the other one was evil.

Ironically, after the hotel opened in 1987 there was one room on that third floor that was almost never rented out. It seems something was always broken in that room. The heat or air conditioning didn't work, or the faucet in the bathtub wouldn't run, or the lights would blink and then go out. The hotel finally gave up trying to rent out the room at all. They called it the "cursed room."

When the Wiccan night watchman told the high priestess about the problem with the room on the third floor, she said that she understood the situation. The two spirits had moved from the hallway into that room when the hotel opened. The spirit who was always breaking things was not the evil spirit. It was the good spirit trying to keep the hotel from renting out the room so that the evil spirit could not bring harm to anyone.

"He is a guardian spirit," she said.

The Heritage Hotel is an independently owned and operated hotel including seventy-one rooms, ten of which are suites. All three floors of the hotel are in use today, and the current managers are very aware of the spirits who may walk the halls of the beautiful old hotel.

Most sightings have been reported on the third-floor landing at the rear of the hotel. One ghost that has been reported is that of a little girl, somewhere in the neighborhood of eight to twelve years of age, whose name was Sarah Ratcliff. According to a visiting psychic, the young girl came from a very wealthy family, and her mother brought her to visit St. Petersburg often for the sake of her health. The psychic believes that the child was a victim of polio in the 1940s, and although she did not die in the hotel, she returns because it was the site of early happy memories. She is most frequently seen in December and April, which would have been the time her family would have visited Florida.

An old woman in a wheelchair has also been seen, along with a ghostly attendant. The psychic said that this is the spirit of a well-loved woman who did die in the hotel. She was admired by her contemporaries for her kindness, but also for her wicked sense of humor. Her name was Mary,

The lobby of the Heritage Hotel. Guests often say they find the portrait over the fireplace disturbing. *Courtesy of the Heritage Hotel.*

or perhaps Marry. Could this good and gentle spirit, with her talent for amusement, perhaps be the shade of the original owner, Dr. Marry Davis herself? We cannot know for certain.

The current general manager, Lynda Rucker, has another interesting anecdote about the hotel. Part of the property includes a restaurant building next door. Although there is currently no restaurant in the building, the last time it was remodeled, it was known as Jillian's. An antique wood sideboard was brought in to be part of the bar. According to Lynda, this piece actually was once the property of Jefferson Davis, the president of the Confederate States of America during the Civil War. The sideboard came from his estate in Biloxi, Mississippi. During the time that Jillian's was open, the bartenders and servers always hated to be around this old piece of history. They reported strange happenings, like glasses and bottles dropping off the shelves for no reason.

In the lobby of the Heritage Hotel, there is a large fireplace, reminiscent of a bygone era. Above the fireplace hangs the portrait of a woman with dark hair and beautiful eyes. Lynda says that both staff and guests have complained that the portrait makes them uncomfortable for some unknown reason. Could the portrait have a connection with one of the ghosts that lingers in the hallways of the Heritage Hotel?

Author's note: The Martha Washington Hotel is now known as the Indigo Inn. The mysterious portrait has been removed, and its current whereabouts is unknown.

Haslam's Book Store

Right on Central Avenue in St. Petersburg sits the largest independent bookstore in the Southeast. John and Mary Haslam founded Haslam's Book Store in 1933 at the height of the Great Depression. Today it covers over thirty thousand square feet with over 300,000 volumes, both new and used. It remains a family business, as three generations of Haslams have worked at the bookstore. No visit to St. Petersburg would be complete without spending time at Haslam's.

One of the stores most famous customers was a man named Jack Kerouac. Born on March 12, 1922, he was a true American Renaissance man. A novelist and poet, he was considered by many to be the voice of the beat generation of the 1950s and '60s. Of course, Haslam's Book Store always carried his works. *On the Road* sold particularly well.

Toward the end of his life Kerouac moved to St. Petersburg. He would often stop by at Haslam's and became friends with the owners. However, Jack did have one annoying habit. He would move all the copies of his works from their proper place (in alphabetical order by author) and set them on the shelves at eye level. He believed his books would sell better in this more advantageous location. The owners knew that after a visit from Jack they would need to go and put his books back in their proper places.

In 1969, at the age of forty-seven, Jack Kerouac died in St. Petersburg of an internal hemorrhage, most likely brought on by years of drug and alcohol abuse. Apparently, however, he is still concerned about the placement of his books on the shelves at Haslam's Book Store.

According to current staff, books in the "K section" often mysteriously tumble down from the shelves, sometimes overnight while the store is closed, but often during the day when there are customers around. Both staff and customers have claimed to feel a presence behind them, as if someone were staring at the back of their heads. Some even claim that they felt a distinctive tap on the shoulder. Yet, when they turn around, there is no one there.

The local paranormal investigative society S.P.I.R.I.T.S. of St. Petersburg did conduct an exploration of Haslam's Book Store. They felt the strongest presence in the southwest section of the building, which houses the how-to books. They were drawn to the area from the minute they entered the building. They heard noises in the area, even though there was no one there. One of the investigators saw a vision of a middle-aged man with gray hair, which was bushy on the sides. Could it have been Jack Kerouac?

BED AND BREAKFAST STORIES

THE LARRELLE HOUSE BED AND BREAKFAST

The home at 237 Sixth Avenue Northeast was built in 1908 for Nimrod (what kind of mother would name her child Nimrod?) and Anne Longley. It is an excellent example of the Queen Anne style of architecture. The couple was already elderly when they moved into the home, and Anne died in the house in 1915 at the age of seventy-four. After her death, the neighbors said that it seemed that Nimrod had lost his mind, for he roamed the halls of the large house, miserable and lonely without his beloved wife. Often he would go to the widow's walk on the top of the house and gaze out over the yards and streets, as if looking for Anne. Finally, he too left this earth in 1919 at the age of eighty-two.

The house has only recently been turned into a bed and breakfast. The name Larrelle House is a combination of the two first names of the new owners, Larry and Ellen. They say that they do not believe in ghosts, yet they reported several strange phenomena within the walls of this grand old house.

They have felt cold drafts flowing through the halls on several occasions. And lights have turned on and off by themselves for no reason. During the renovation of the house, tools would disappear, only to turn up in very odd places, as if they had been moved by an unseen hand. Perhaps Nimrod wanted his house left just the way it was, regardless of its state of disrepair.

The innkeepers live on the third floor with their cat. The cat has been known to spend hours staring at the same spot on the ceiling. Does he hear the quiet footsteps of a ghost on the widow's walk?

One of the local spirit investigation societies is very interested in the Larrelle House. This group stated positively that the house is haunted. They noted that the thermometers they carried indicated a very definite temperature change in front of the house. They also claimed to feel the presence of a sad and lonely spirit looking out of the third-floor windows.

Anne and Nimrod are buried side by side in the nearby historic Greenwood Cemetery. Does one or both of them like to rise and return to the site of their happy home?

MANSION HOUSE

The beautiful bed and breakfast at 105 Fifth Avenue Northeast is actually two houses that are a mirror image of each other. The house on the corner was actually built sometime between 1901 and 1904 for the first mayor of St. Petersburg, David Moffett. The other house was built elsewhere and moved to this spot. A lovely courtyard now graces the yard

between the two houses. The couple that renovated these homes into an inn was from Wales, and they named the place the Mansion House because to the British that means the house of the mayor.

Moffett was an Indiana-born farmer who came to St. Petersburg in 1881. At the time there was a lot of controversy about whether St. Petersburg should be incorporated as a town. Some folks worried about the taxes and new laws that official status as a town might bring. But on February 29, 1892, by a vote of fifteen to eleven, the white male citizens of St. Petersburg (the only ones allowed to vote) approved incorporation. This date actually represents poor planning, as it means the city can only celebrate the actual anniversary of its incorporation every four years. However, the citizens of the new town didn't let any grass grow under their feet. Within a few hours they had elected Moffett as mayor, as well as five councilmen.

But the controversy did not end there. John Williams, one of the founders of the town, had been Moffett's opponent in the mayoral race. Williams, whose own father had been the first mayor of Detroit, Michigan, was not happy with this turn of events and protested the validity of the mayoral election…but not for long. He died on April 25, 1892. Although the actual cause of his death is unknown, some speculate that the disappointment and humiliation was just too much for him.

Moffett served only one year as mayor. But he also served on the city council for several years and was superintendent of schools. However, the dearest cause to his heart was temperance. He believed that the drinking of alcohol was the root of nearly all the evils in society. He worked tirelessly to rid the world of "demon rum" until the day of his death in 1921. He is buried in Greenwood Cemetery.

But there are some who say his spirit is displeased with the path the city has taken. The bars and restaurants that serve liquor would surely be an anathema to him. Previous owners of the Mansion House reported that some of their guests felt that someone was peering over their shoulders with a strong sense of disapproval when they were sipping an alcoholic beverage. Could the temperance-minded mayor be trying to make his presence felt?

The current owners say they have had no encounters with Mayor Moffett or any other spirit in the house. They suggest that people should spend a night in the graceful mansion and find out for themselves. But perhaps you should leave that bottle of champagne at home.

THE BEACH DRIVE INN

The former home of Aymer Vinoy Laughner, at 532 Beach Drive Northeast, is now also a bed and breakfast. It is known as the Beach Drive Inn and celebrated its grand opening quite recently, in July of 2007. The

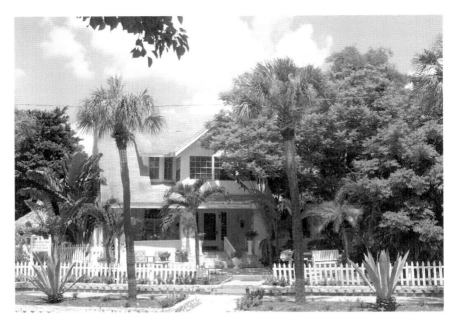

The Beach Drive Inn, once the home of Aymer Vinoy Laughner. *Photograph by the author.*

owners, Roland and Heather, offer six elegantly decorated rooms for guests as well as a lovely front veranda with comfortable rocking chairs.

If you would like to meet a ghost, ask for the Montego Bay Room. This room is at the back of the house, and in the original days of the house, it would have been the maids' quarters. According to legend, one of the maids of the Laughner family was prone to overconsumption of alcoholic beverages. After she had completed her duties for the day, this maid would often retire to her room, sit in her rocking chair and drink herself into a pleasant haze. After a time, this clandestine activity caught up with her, and her employers fired her.

Apparently, however, she often returns to the scene of her former debauchery. Her presence has been sensed by several people in the Montego Bay Room. And the rocking chair that sits in the room has been seen to move back and forth without any visible means of propulsion. Heather's mother even says she has seen the shadow of the drunken maid cast upon the wall of the room.

If you would rather not encounter a ghost, don't let that stop you from paying a visit to the Beach Drive Inn. There have been no reports of any kind of haunting in any of the other rooms.

The Ghosts of Clearwater

Clearwater is smaller than St. Petersburg, and much smaller than Tampa, their larger sister city across the bay. It sits very near the center of the Pinellas Peninsula, and it has a strong reputation as a tourist destination, with its miles of beautiful beaches and elegant hotels and resorts. First incorporated as a city in 1891, it became the county seat on the day that the peninsula broke away from Hillsborough County to become Pinellas County in January of 1912. There is some speculation among historians that Clearwater would only agree to the formation of the new county if it could be the seat of that county government.

The development of Clearwater got a huge boost with the arrival of Henry B. Plant's railroad, which began passenger service to the city in 1888. And another boost came when that same gentleman built a truly grand hotel there in 1897.

Today, a large portion of downtown Clearwater is owned by the Church of Scientology. Using an assumed name, the church purchased the Fort Harrison Hotel in 1975 and has acquired a great deal of land since then. Today they have a complex of over forty buildings from which advanced services of the church are offered to members who come from all over the world.

Although many of the smaller mom and pop hotels are being replaced by condominiums, Clearwater remains one of the best places in Florida to visit. In fact, it was recently named the "Best City Beach on the Gulf of Mexico." Sun, sand, surf and spirits abound.

The Belleview Biltmore

When you catch your first glimpse of the Belleview Biltmore, it takes your breath away. It stands serenely among the trees, an enormous Victorian confection, gleaming white in the Florida sun.

New York entrepreneur and railroad tycoon, Henry B. Plant, and his son Morton Plant built the Belleview Biltmore in 1896. Constructed from the heart pine native to this area, it is the world's largest occupied wooden structure. The hotel is a monument to the opulence that characterized the waning years of the nineteenth century. Here guests such as Thomas Edison, the du Ponts and the Vanderbilts whiled away their leisure hours on the fabulous golf course or sunny porches and luxurious rooms. Open each year only for the season of January, February and part of March, it was a home away from home for the wealthy and elite well into the twentieth century.

Of course, over the years some guests have simply chosen to remain behind, even after their deaths. A member of the staff, who describes herself as a skeptic, told me that several event planners and guests have shared their stories of strange happenings within the hotel. One evening, a group of wedding guests was sitting in a two-room suite with an interconnecting door. All the members of the group suddenly noticed a strange odor. The smell of smoke was drifting in from the adjoining room. When the group looked into the other room, they saw no smoke, even though the odor continued to hang in the air. When they looked at the cushions of one of the chairs, there was a definite indentation that had not been there before, as if someone had sat down in the chair, perhaps to enjoy a rest and a smoke. A few moments later, even as they watched, the chair cushion returned to its previous state as the indentation vanished. The smell of smoke disappeared at the same moment. Perhaps this unexpected guest had finished his rest and left them to walk the two miles of corridors that run through the beautiful old hotel.

Another staff member, a security guard named Lary, was also quick to offer a story. According to him, sometime in 1922, a fabulous wedding was planned to take place in the hotel. The couple had booked what was then the bridal suite, room 4336. Sadly, the groom and his friends had decided to motor into Tampa for a bachelor party the night before the wedding. On their way back to the hotel, in the wee hours of the morning, the groom was killed in an unfortunate automobile accident.

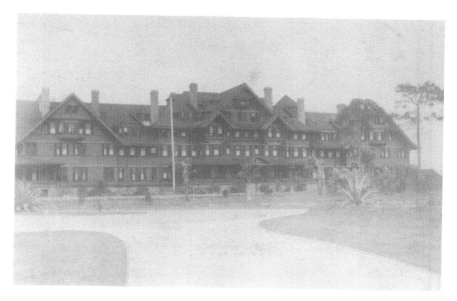

The Belleview Biltmore in 1898, just one year after its construction. The dark color is the result of the weathering of the pine from which the hotel was built. It would not be painted white until many years later. *Courtesy of the St. Petersburg Museum of History and the Belleview Biltmore Hotel.*

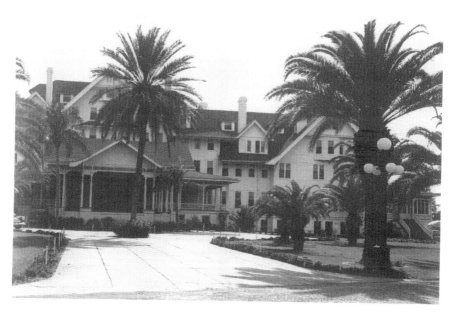

The front veranda of the Belleview Biltmore as it appeared in 1950. *Courtesy of the St. Petersburg Museum of History and the Belleview Biltmore Hotel.*

The bride, a lovely young girl named Mary, did not hear of the death of her intended until after she had dressed in her flowing white wedding gown in preparation for the ceremony. Distraught when she heard the terrible news, she leapt to her death from the balcony of room 4336.

While this story is an undocumented legend of the hotel, and there is no proof that this incident ever occurred, many guests and staff have reported seeing Mary wearing her wedding gown, and wandering along the grounds and hallways of the hotel. According to Lary, back in 1997, a wedding photographer was strolling the grounds selecting locations to shoot pictures of the wedding party after the ceremony. He snapped a few quick shots of some stately old trees that he thought were promising sites for formal pictures. When he developed the film later, he saw the image of a young woman in an early 1920s-style wedding dress staring back at him from the pictures. Is Mary posing for those formal wedding pictures that she did not live to take?

But the most interesting ghost story of the Belleview Biltmore involves the wife of Morton Plant, one of the hotel's builders. In 1913, Morton happened to meet a beautiful young woman named Maisie. Morton was immediately smitten. The problem was Maisie was already married to a fellow named Sheldon Manwaring at the time. According to the Belleview Biltmore's historian, Morton paid Manwaring $8 million to quietly step aside and grant Maisie a divorce, freeing her to marry Plant. As a wedding gift, Plant gave his new bride the New York mansion that he had built on the corner of Fifth Avenue and Fifty-second Street. Maisie must really have been something!

In 1916, while in New York, Maisie went to a jewelry exhibit held by a jeweler newly arrived from Paris, one Monsieur Henri Cartier. She fell head over heels in love with a double strand necklace of perfectly matched natural pearls. But the price tag was a bit steep, $1.2 million. Even Maisie's doting husband was not willing to shell out that much for a necklace. Undeterred, Maisie traded her New York Fifth Avenue mansion for the necklace. Cartier Jewelers operates out of that mansion to this very day.

There is no record of what Morton Plant thought of his wife's exchange. According to legend, on some later unknown date, Maisie lost her pearls somewhere in the Belleview Biltmore. And to this day, she wanders the halls looking for them. She appears in late Victorian-era dress. Sometimes she carries a parasol over her shoulder.

A large framed portrait of the beautiful Maisie hangs in the Palm Grill Restaurant on the first floor of the old hotel. A recent visitor admired

The Belleview Biltmore Hotel in its early years. Note the train in front of the hotel. *Courtesy of the St. Petersburg Museum of History and the Belleview Biltmore Hotel.*

the painting and decided to take a picture of the image. The digital photographs taken at that time show a soft, flowing white mist in front of the portrait. This mist was not present either in actuality or in the viewfinder of the camera. Perhaps Maisie wanted the photographer to know that she is still looking for that famous strand of pearls.

The beautiful Belleview Biltmore closed in 2009. But not forever. The new owners have promised a complete renovation of the first floor and a renovation of the upper floors. Who knows—perhaps they may even find those long lost pearls.

Fort Harrison Hotel

It was nearly thirty years before Clearwater would get a second grand hotel. The new edifice was built right downtown, with a fabulous view of the beach and the Gulf. In 1925, a local land developer and real estate broker named Ed Haley began construction on a massive high-rise building that he would christen the Fort Harrison. The name recalls the early pioneer history of the area, when there was an actual fort named Fort Harrison in what would later become Clearwater. The fort itself was named after the ninth president of the United States, William Henry Harrison.

When the grand opening was held on December 31, 1926, the new eleven-story hotel was described as the "Aristocrat of Florida Hotels." Throughout all the boom and bust years that followed, and through several different owners, the Fort Harrison was the most luxurious hotel in Clearwater. For a time, it even surpassed the Belleview Biltmore in grandeur, although it was built in a very different style from the older hotel.

In 1965 an up-and-coming British rock-and-roll band played a concert in Clearwater. Naturally they had deluxe accommodations at the Fort Harrison Hotel. Unfortunately, all did not go well with the concert. The crowd got so rowdy, throwing toilet paper rolls and bottles, that the Clearwater Police stopped the concert. Even as the band was being whisked back to the hotel, partying teens tried to chase down the fleeing vehicle. The whole incident was so wild and out of control that the Clearwater Recreation Department declared there would never be another such concert in Clearwater.

So the band went back to their hotel room and just settled in for the rest of their stay. In the middle of the night, one of the band members woke up with a driving guitar riff running through his head. He took a few moments to write it down, along with a basic refrain. In the morning he wrote a few more lyrics before the band left the Fort Harrison.

The band was the Rolling Stones. The songwriter was Keith Richards. The riff and lyrics that came to him that night in Clearwater became the first number one hit for the band. The song came to be called "I Can't Get No Satisfaction."

Despite this brush with fame, the Fort Harrison began to show the wear and tear of time. By the 1970s it was in a sad state. In 1975, a group calling itself United Churches of Florida purchased the old building and began a restoration project. Unbeknownst to the city officials who authorized the sale, the real purchaser was the Church of Scientology founded by L. Ron Hubbard. The old Fort Harrison became an important part of the Scientology program in the Clearwater area.

In 1995 there was a tragedy within the walls of the old structure when the death of a young woman caused considerable controversy. Lisa McPherson, a Scientologist, had been staying in the church's accommodations at the Fort Harrison. On the seventeenth day of her visit, she was transported by van to an emergency room at a hospital several miles away. She died en route. The official cause of death was a blood clot in the left lung.

Following her death, there was a war of words between Pinellas County prosecutors and the Church of Scientology. Was her death an accident

or homicide? Did the staff at the hotel ignore a serious medical condition that led to Lisa's death? Was the prosecutor's office on a "witch hunt" to discredit the church?

The circumstances were strange by any measure. Apparently, Lisa had been involved in an automobile accident. According to church officials her seventeen-day stay was simply for rest and relaxation, with room service and other amenities at her disposal. According to other accounts, Lisa was in severe distress of some kind, whether emotional or physical. At times she claimed to be L. Ron Hubbard, the founder of Scientology. She refused to eat, spitting out food that was given to her.

Charges against the church were eventually dropped, ostensibly because of mistakes made by the medical examiner in the case. It is likely that the full truth will never be known about this case.

Since the day of her death, however, Lisa McPherson reportedly walks the halls of the old Fort Harrison Hotel. She is seen occasionally peering out of one of the upper-story windows. However, she is more frequently heard than seen. The sound of a woman's voice has been reported, sometimes raised to a fever pitch, as if in delirium. It is possible this ghost is from long ago. But it is more likely Lisa McPherson who has yet to get "satisfaction" regarding the circumstances of her own death.

SAFETY HARBOR RESORT AND SPA

By all historical accounts, the first European to visit Florida was Ponce de León, who arrived in 1513 on our shores somewhere close to what is now St. Augustine, near the St. John's River. Contrary to legend, however, he was not searching for the Fountain of Youth. He was after land, wealth and precious metals. He did give the state its name, calling it La Florida, most likely in honor of the Spanish holiday, Pascua Florida, which means feast of the flowers.

A few years later in 1539, another Spanish explorer, Hernando de Soto, reached the shores of Old Tampa Bay. When he arrived he believed that he had indeed found what legend says Ponce de León sought, for he discovered a cluster of natural springs near what would one day become the city of Clearwater. He believed these five mineral springs had healing powers and he named them the Springs of the Holy Spirit. According to legend, he believed the springs were the Fountain of Youth.

Over the years, this area and these springs developed a reputation as a place where good health could be restored. Indeed according to legend in the years before the Civil War, a local farmer named Jesse Green benefited so much from taking the waters that his crippled legs began to function once more and he could once again farm his land. For years thereafter, the area was known as Green's Springs.

The springs had several different owners and over time buildings were built to enclose the healing waters and to accommodate the many visitors who came seeking good health. In 1945, Dr. Salem H. Baranoff turned these buildings into a complete resort, which he named the Safety Harbor Spa. He paid $190,000 for the springs, the buildings and eighteen acres of land.

Dr. Baranoff was originally from Kiev, Russia. He immigrated to the United States in 1904. In his youth, he wanted to become a doctor, but his mother wanted him to become a rabbi. Obviously, he followed his own star. His contemporaries described him as a soft-spoken man who was always generous and kind.

He sold his interest in the spa to another doctor, Richard Gubner, in 1952. But he stayed in the area. He passed away on July 26, 1977, at the age of ninety. In 2004, a two-hundred-year-old oak tree near the spa was named the Baranoff Oak in memory and honor of the good doctor.

According to several people who have worked at the Safety Harbor Resort and Spa for years, Dr. Baranoff is still concerned about those who visit Safety Harbor. He has frequently been seen at the spa, especially near the springs themselves. He is described as a gray-haired, soft-spoken gentleman who inquires about the health of a visitor and recommends which healing waters should be used. He has also been seen near the ancient oak that bears his name. No one has anything to fear from the doctor. In fact, if you see him, it might not be a bad idea to ask for a consultation.

Selected Bibliography

Books

Arsenault, Raymond. *St. Petersburg and the Florida Dream, 1888–1950.* Gainesville: University Press of Florida, 1996.

Bethell, John. *History of Pinellas Peninsula.* St. Petersburg: Press of the Independent Job Department, 1914.

Brown, Lynne. *Gulfport: A Definitive History.* Charleston, SC: The History Press, 2004.

French, Thomas. *Unanswered Cries.* New York: St. Martin's Press, 1991.

Hartzell, Scott Taylor. *History of St. Petersburg, Historical and Biographical.* St. Petersburg: Great Outdoors Publishing Company, 1972.

———. *Remembering St. Petersburg, Florida: Sunshine Stories.* Charleston, SC: The History Press, 2006.

Hurley, Frank T., Jr. *Surf, Sand & Postcard Sunsets.* 2nd revised edition, 1989.

Miller, Captain Bill. *Tampa Triangle Dead Zone.* St. Petersburg: Ticket to Adventure, Inc., 1997.

Reeser, Tim. *Ghost Stories of St. Petersburg, Florida.* St. Petersburg: 1ˢᵗ Sight Press, 2004.

Reynolds, Kelly. *Henry Plant, Pioneer Empire Builder.* Cocoa: The Florida Historical Society Press, 2003.

Young, June Hurley. *The Don Ce-Sar Story.* St. Petersburg: Partnership Press, 1974.

Newspapers and Periodicals

Gulfport Gabber
Island Reporter
St. Petersburg Times
Seabreeze

Visit us at
www.historypress.net

..

This title is also available as an e-book